ART
of
STILL LIFE
DRAWING

Translated from the Spanish by Edgar Loy Frankbonner

Library of Congress Cataloging-in-Publication Data Available

10 9 8 7 6 5 4 3 2

Published in 2006 by Sterling Publishing Co., Inc.
387 Park Avenue South, New York, NY 10016
Originally published in Spain in 2005 under the title *Dibujo de Bodegón*
by Paramón Ediciones, S.A., Barcelona, Spain
Text: David Sanmiguel
Drawings and exercises: Carlant, Mercedes Gaspar, Esther Olivé, Óscar Sanchís, David Sanmiguel
Photographies: Nos & Soto
Copyright © 2005 by Paramón Ediciones, S.A.
English Translation Copyright © 2006 by Sterling Publishing Co., Inc.
Distributed in Canada by Sterling Publishing
c/o Canadian Manda Group, 165 Dufferin Street
Toronto, Ontario, Canada M6K 3H6
Distributed in the United Kingdom by GMC Distribution Services
Castle Place, 166 High Street, Lewes, East Sussex, England, BN7 1XU
Distributed in Australia by Capricorn Link (Australia) Pty Ltd.
P.O. Box 704, Windsor, NSW 2756, Australia

Sterling ISBN 13: 978-1-4027-3284-3
Sterling ISBN 10: 1-4027-3284-8

ART *of*
STILL LIFE DRAWING

STERLING

New York / London
www.sterlingpublishing.com

Contents

Introduction

STILL LIFE *and the*
INTERPLAY OF FORMS

The still life once occupied a modest secondary place within the hierarchy of academic genres. The old masters painted many still lifes, but they served only as props in their great figurative compositions. As a result, few of these drawings survived prior to Impressionism, and some art historians consider still life a minor genre when compared to landscape and, even more so, to figure drawing. Nonetheless, one need only to think of artists such as Chardin, Cézanne, Braque, or Morandi—all consummate painters of still lifes—to realize that this is far from the truth.

No matter how humble and ordinary they may seem, the objects in a still life always answer to a sense of form, style, and harmony.

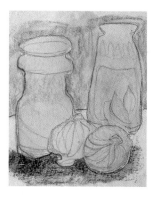

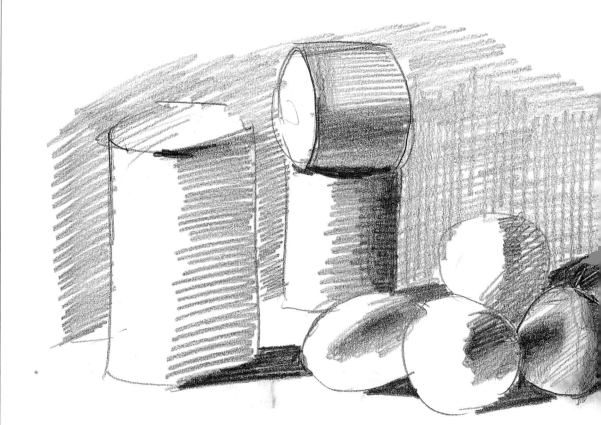

The still life's role in art is extremely important, as it measures the artist's ingenuity and aesthetic imagination. The essence of a still life lies in the interplay of its forms—light and shadow, contours, volumes, and so on. In the hands of a true artist, this interplay is full of life, enlivened by a creativity that can turn the simplest group of objects into expressive, meaningful signs—a little universe of sensual, tactile forms. The ability to do so comes from knowing how to make proper use of the fundamentals of drawing.

These fundamentals, among others, are the subject of *Art of Still Life Drawing*. From basic line drawings of simple objects to the most sophisticated chiaroscuro effects, this book is designed to show the reader everything he or she needs to know about drawing a still life. Many illustrated examples in diverse styles are accompanied by specific, step-by-step explanations of each technique and process. In short, this book aims to show the appeal of the still life to beginning artists whose familiarity with still life drawing has been limited, and to inspire more experienced artists with new possibilities.

THE BASIC

Drawing

"What an artist must seek most of all is to create a work which, after much toil, appears to have been made quickly and with great ease."

Michelangelo (1475–1564)

GUIDELINES FOR

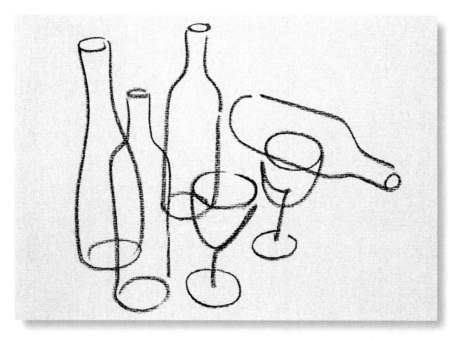

Still Life DRAWING

One of the keys to success in still life drawing is to master—and appreciate—the representation of simple forms. The art of the still life is often a simple one: humble objects drawn in a simple manner. But to draw with simplicity does not mean drawing any which way you please. The principles of order, symmetry, proportion, and perspective should be implicit in every line, and only after an exhaustive study of these principles will you be in a position to stop being conscious about them and draw naturally and spontaneously. The learning process is slow and step-by-step, but the techniques you'll learn here will allow you to go far and move a lot more quickly than you might expect.

BASICS *of* CHOOSING A SUBJECT

Virtually any representational work other than a landscape or figure drawing is considered a still life. The objects you see on a tabletop—a desk, a café table, or any kind of table for that matter—can inspire an interesting drawing. It's a matter of "seeing" the drawing beforehand, hidden as it may be within a clutter of visual information. That information includes light and shadow, perspective, flat and curved surfaces, different materials, color, shine, and transparencies. This glut of features can be distracting, so it is crucial to ignore the superfluous elements in your subject and concentrate on what is essential. This is one of the artist's biggest challenges.

Characterization

Real objects are full of detail and changing features—light and shadow, changes in shape depending on one's point of view, and so on. You need not—and should not—represent all of these simultaneously. The interesting aspects of each object are its characteristics, the features that allow you to identify it immediately. To render the characteristics, all you need is a few basic drawing techniques: a lemon is an elliptical shape with two protuberances, one at either end; the silhouette of an apple resembles a heart; and a water glass is a clear cylinder that widens at the top. The simpler the drawing, the easier it is to recognize the object. It is a matter of reducing the representation of each object to a pictogram that immediately communicates its particular shape.

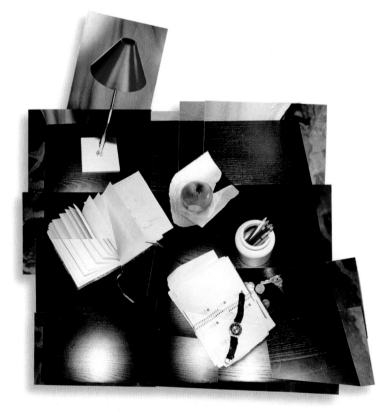

Above: A photo montage showing the way in which ordinary objects present themselves to us: out of order and disorganized. Your first task as an artist is to clear away the clutter to achieve clarity and simplicity in your drawing.

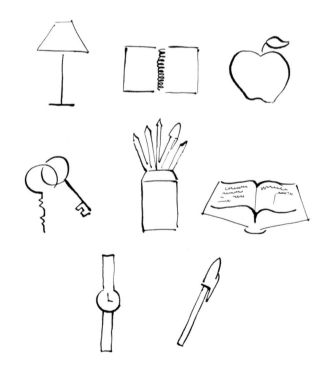

Above: The objects in the photograph can be simplified and reduced to readily identifiable pictograms. To accomplish this all you need is a few basic drawing techniques.

Groupings

Once you have gathered some of objects and drawn their pictograms, you can arrange a grouping however you like—by varying the point of view and the position of the objects, adjusting the size of the objects, the distance between them, and so forth. Little by little, you can add aspects that enrich the grouping: shading, details, perspective, and anything else that does not disfigure the unique shape of each object. In this book we will start with simple techniques and proceed to more elaborate ones.

An object can be reduced to any number of pictograms, each of which communicates its essential characteristics.

The key to drawing pictograms lies in the freedom and daring of the artist. There is no reason not to exaggerate sizes or distort forms. The important thing is for each object to be immediately identifiable among the others. Matters of proportion and placement do not come into play here.

The heart of drawing lies in embellishing. Here we have darkened some parts of the basic pictogram to achieve a more realistic look.

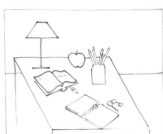

Organizing pictograms in an orderly composition is easy. All you need to do is coordinate their respective sizes and group them logically.

The diagonals of this table suggest a perspective that adds a level of realism to the arrangement of the pictograms.

When a pictographic composition is embellished with differently lighted areas, we achieve a still life in its simplest state.

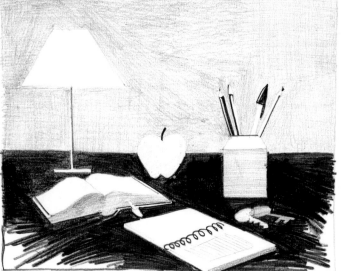
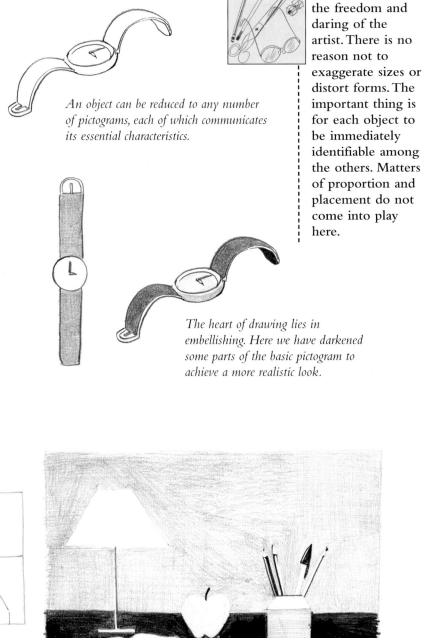

Competence in still life drawing is not a matter of technical virtuosity. The important thing is to have clear ideas and to reduce the subject to its elementary parts.

DRAWING CONTOURS

The basic drawing of an object, which we call a pictogram, can be done quickly and intuitively. But you can also take this simple drawing more seriously, paying special attention to its contour lines and its proportions. The result is still a highly schematic drawing, but it has a greater degree of realism. Drawing contours will prepare you for drawing symmetrical objects.

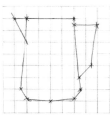

First chart the most important points of the object's contour on a piece of graph paper, paying special attention to the equivalent proportions of its left and right sides: its symmetry.

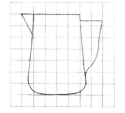

Join the points with a contoured line that represents the silhouette of the object.

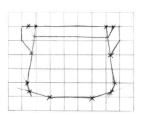

Symmetrical objects are easy to draw using graph paper. All you have to do is count the number of squares on either side of a temporary or imaginary middle line, mark the points of inflection, and trace the contours.

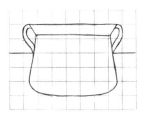

The drawing is finished when you smooth out the contour suggested by the points you previously marked on the graph paper.

To draw an elementary object like a vase on graph paper, first join the points of reference and then round out the contours. A pair of ovals at the top and bottom indicates the three-dimensionality of the object. To finish, apply an intuitive shading.

The method of drawing contours on graph paper works with any still life subject. Even if the shapes are not entirely symmetrical, it is easy to complete a still life based on simple pictograms.

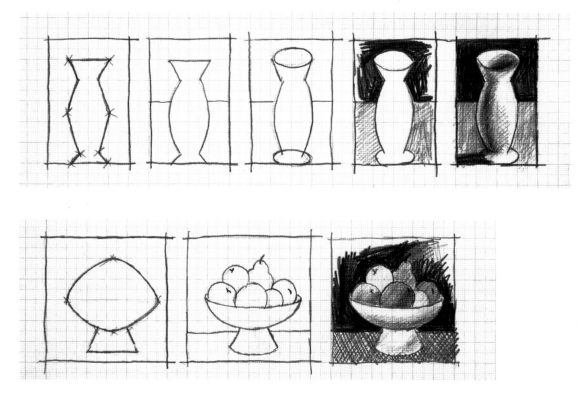

The Line of Symmetry

Many objects are symmetrical. Symmetry is easier to realize if the drawing is done on graph paper, where you can achieve perfect symmetry and proportion. After practicing the graph paper exercises shown here, you will soon be able to draw freehand on regular drawing paper.

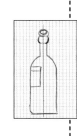

Exercises in drawing symmetries can be based on real objects, on free interpretations of those objects, and even on imaginary objects. Any straight line drawn at random on a piece of graph paper can yield a symmetrical object.

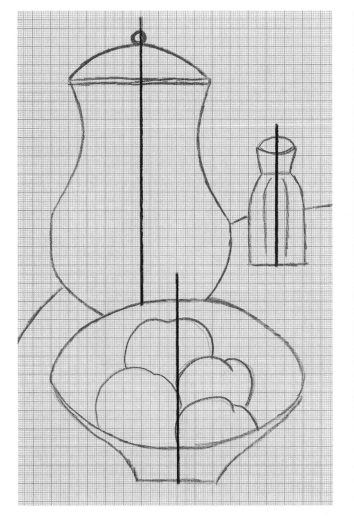

This is the preliminary step to an elaborate drawing of several objects arranged on a tabletop. The lines of symmetry are in blue.

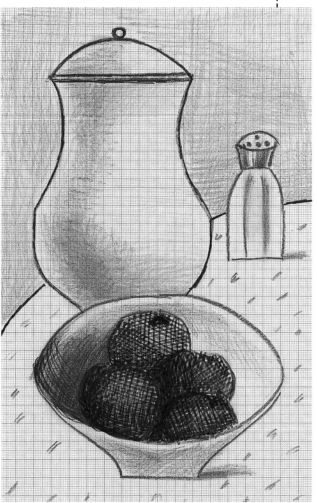

Once you have rendered the symmetrical objects, you can finish the drawing however you please. In this exercise, the approach is not to seek absolute realism, but to complete a drawing that represents the integrity of the contour lines.

USING LINES *to*
DEVELOP DRAWINGS

The use of graph paper not only ensures that the contours and proportions of the drawing are correct, but also makes composition easier. The space between objects is clearer when marked by straight lines on the paper—and also make it easier to arrange the objects. This way, you learn to avoid empty or cluttered spaces on the page, and also how to depict both the object or objects you are representing within the drawing as an integrated, harmonious whole.

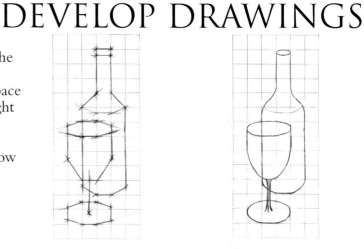

Containers usually have a cylindrical shape, and often entail the drawing of ellipses. This image shows how those shapes can be created using the graph paper method.

After marking all the contour reference points of the object, round out the silhouette to finish the drawing.

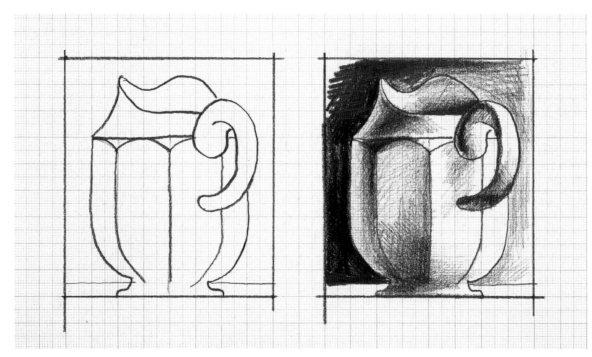

More complex objects shouldn't be a problem if drawn laterally on graph paper without reference to perspective. In this case, the object featured has curved lines which, when properly represented, help suggest its three-dimensionality.

Curves, Circles, and Ellipses

In a line drawing, curves are the only possible indicators of three-dimensionality. A curved form suggests volume, and the correct drawing of curved lines ensures correct proportions. Still lifes tend to be composed of multiple cylindrical objects, so it is important to master the drawing of circles and ellipses. Ellipses represent the circle as seen in perspective and demonstrate the three-dimensionality of the drawing.

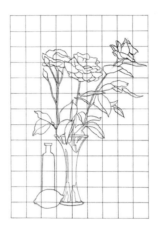

Drawing a circle is easy when working within a square figure that is drawn on a grid. And so is drawing a circle with perspective—in other words, an ellipsis. First draw a rectangle. Then draw with a cross in the center of the rectangle to indicate the lines of symmetry. Proceed as if you were drawing a circle, making sure to flatten the upper and lower ends of the figure and to stretch out the sides.

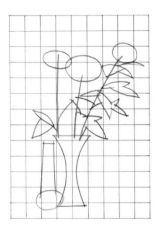

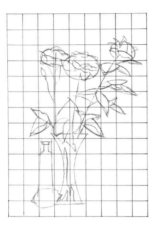

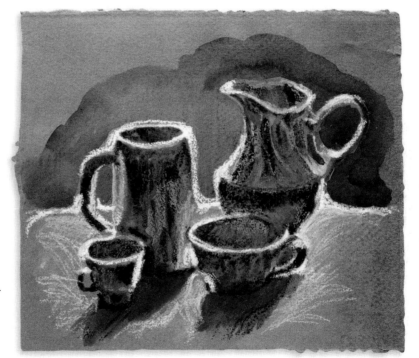

When drawing groups of different shapes on graph paper, proceed just as you would with individual shapes, making sure to arrange the objects logically according to their size and proportion.

First draw the flowers as ovals, in order to depict their perspective, and then adjust their shape using the guidelines provided by the grid.

Since this is a complex drawing that requires great care and patience to establish all of its details, work on graph paper that isn't too thin, so that it allows you to erase as many times over as you need.

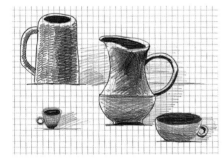

The interesting combination of sizes and shapes in this grouping of containers highlights the distinct ellipses of their mouths.

The arrangement of objects in a finished work depends on your personal style, but the underlying principle of every still life drawing always remains the same: the correct drawing of simple forms in proper perspective.

Pictograms are useful when drawing groups of objects that have a determinate spatial relationship. In this example, we go beyond a "shoulder-to-shoulder" arrangement of objects and draw the various vases and cups at different heights to suggest the dimension of space. In a spatial relationship, the lowest object in the drawing appears to be in front of the highest, and the object in the highest position appears to be in the distance. It isn't necessary to modify the size of each shape. Each element can be drawn just as it would be in an isolated representation.

SPATIAL RELATIONSHIPS
AMONG OBJECTS

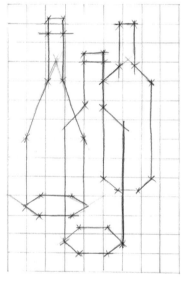

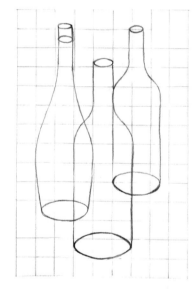

The position of the pictograms at different heights suggests a spatial relationship in which the more elevated objects appear more distant than the objects positioned lower on the page.

The most obvious compositional arrangement is to line the objects up as in a frieze. Arranged side by side, the objects' silhouettes are perfectly defined. The appeal and interest of this grouping is provided by the contrasts between the shape and size of each different element.

Groupings and Compositions

Interpreting the spatial relationships between objects allows us to develop diverse groupings in a composition. It isn't necessary to lay out a complete still life on your tabletop before beginning to draw. Instead, you can bring together different pictograms within the drawing and make modifications in their height within the composition. The result produces an immediate, intuitive sense of the meaning of the terms *grouping* and *composition*—and an increased sense of harmony.

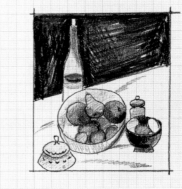

Freedom within the grouping of the pictograms produces simple results with graphic appeal. Spatial relationships should take precedence, even if it means sacrificing the precision of the contours.

Following the basic compositional principle according to which objects that are higher in the composition appear more distant, you can create countless drawings with a greater or lesser number of different objects.

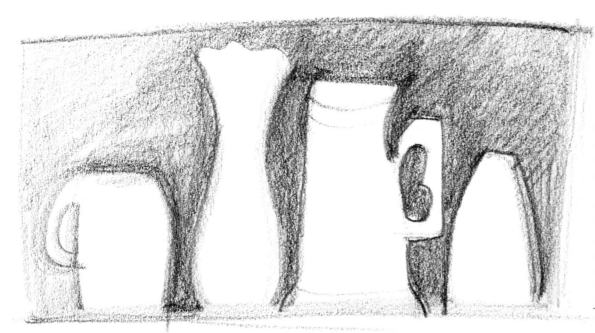

When the contour, width, and height of objects are in high contrast, the silhouettes alone are sufficient to create a certain charm and a genuine compositional interest. A drawing such as this can be considered in itself already a finished work and requires no further elaboration.

PERSPECTIVE *in* STILL LIFE

Perspective, in the most orthodox sense, can be defined as a plane where lines converge at one or two points on the horizon. The tiles on this plane suggest a progressive diminution in size.

Perspective is indispensable for representing objects in space. There are many forms of perspective. The most complex involve the representation of grand architectural spaces in which distances are vast. The vanishing points (the convergence of lines at a point in the horizon) in these types of perspective do not apply here, however, to still lifes, since the objects in still lifes are much smaller (the smaller dimensions of objects in a still life do not require them). Vanishing points or lines evident in a view of a building or a street are unnecessary in a view of a box, vase, or bottle.

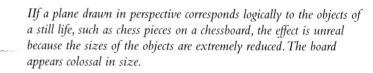

IIf a plane drawn in perspective corresponds logically to the objects of a still life, such as chess pieces on a chessboard, the effect is unreal because the sizes of the objects are extremely reduced. The board appears colossal in size.

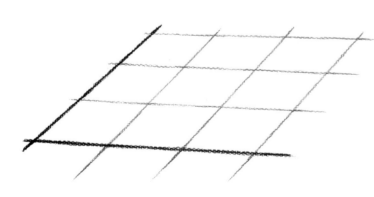

Orthodox perspective does correspond to the normal appearance of objects in a still life, however. We can now see the chessmen in their proper dimensions.

A plane based on the substitution of parallel diagonal lines for vanishing lines creates a pattern of same-sized tiles.

Basic Perspective Method

When drawing still lifes, all that you need is to apply a basic, intuitive principle of perspective. The vanishing lines in a still life are merely diagonal parallel lines that are placed at an approximately 45-degree angle to the object's face. Apply this simple rule and you'll be able to draw any object requiring an adequate sense of depth.

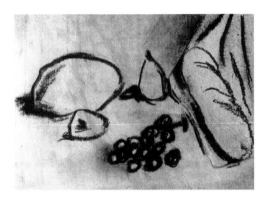

Because they are usually placed at an equal height, the points of view of a still life do not allow objects to appear in perspective with vanishing points, vanishing lines, and horizon.

An object or composition can do away with perspective entirely and assume a flat form in which the play of silhouettes achieves sufficient harmony and aesthetic appeal.

The simplest way to create a view in perspective is to begin with parallel "vanishing lines" at about a 45-degree angle relative to a horizontal line. Although fairly schematic, the effect is not at all unrealistic if the still life is drawn correctly; the elements of the composition, all of them fairly small, are too close to the viewer for the convergence of the actual vanishing lines to be evident.

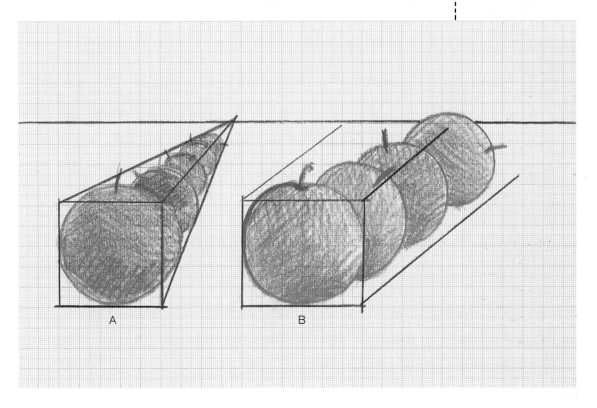

Vanishing points (A) produce a distorted result in representations of the space between small objects, such as the fruit in this drawing. The use of diagonal lines (B) produces far more logical results.

Basic

DAVID SANMIGUEL. *STILL LIFE IN AN INTERIOR*, 2004. CHARCOAL PENCIL.

Solids
AND THE
GEOMETRIC SKETCH

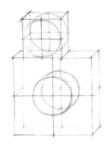

In essence, still life is the art of representing elemental shapes grouped harmoniously. The shape of every ordinary object will resemble a geometric solid, such as a prism, cylinder, cone, or sphere. In order to master form, it is vital for the artist to learn to draw these solids correctly. Once these elementary shapes are understood, it is much easier to complete the drawing of each object. We call this process geometric sketching, and it is the simplest and most practical way to approach the still life with success.

DRAWING GEOMETRIC
SHAPES

Beyond interpreting the pure lines of the contour of the object, we have to learn to interpret the object as a solid body. Following a process that leads from the elemental to the complex, we begin with the most primary forms: hexahedrons (rectangular solid), cylinders, pyramids, and generally, any simple solid with a flat or curved surface. The hexahedron is the easiest to represent. Its surface is flat and all of its edges come together at 90–degree angles. To draw hexahedrons as three-dimensional shapes, the basic rules of perspective are applied.

These wooden cubes are a fitting subject for practicing drawing simple solids. The cubes can be arranged in multiple ways to achieve groups of varying complexity.

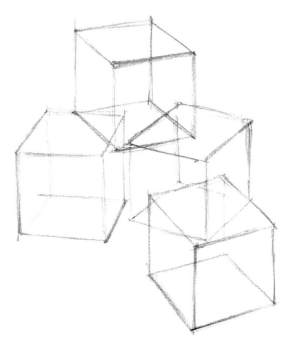

Drawing first in pencil and then in ink, the resolution of a set of blocks consists of viewing the edges of the cubes from a basic perspective, leaving the sides transparent to allow for later adjustments.

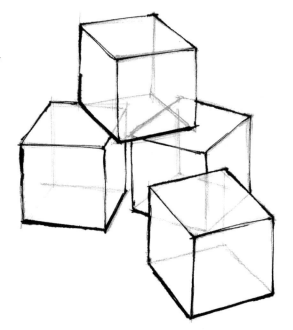

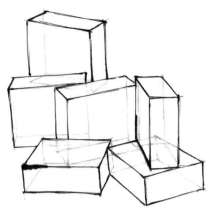

Some Cubist
drawings are
aggregates of
different prisms.
Although their
construction is
never systematic,
the presence of
transparent prisms
is readily
apparent.

Whether we are dealing with cubes or hexahedrons with rectangular sides, the drawing will be based on the parallel lines of their vertical and diagonal edges. It is preferable for all blocks to be the same size.

Clusters

The compelling aspect of drawing simple solids is representing different sets, or clusters, of solids as seen from different angles. Each cluster can suggest the form of a three-dimensional object or inspire an interesting grouping in the still life composition. Drawing from the starting point of a solid geometric body (in this case a hexahedron) forces the imagination to conjure up different objects as more or less complex groupings of these elementary bodies.

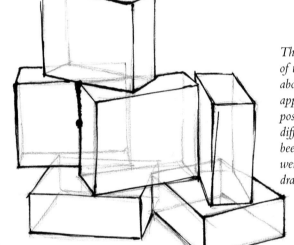

This is another version of the pencil drawing above. Here the units appear to be in different positions because different surfaces have been hidden, as they were not in the first drawing.

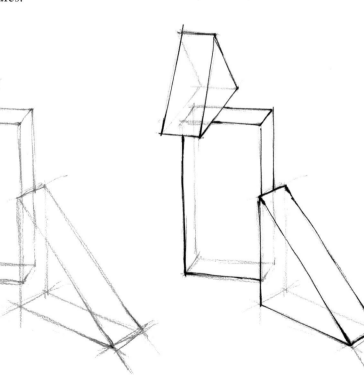

This drawing consists of two triangular prisms and a hexahedron. Triangular prisms can be drawn if you first draw a hexahedron and then split it diagonally.

We can also group simple solid shapes for a closer approximation of the diversity of real shapes. These solids can be hexahedrons with different proportions, or cylinders, pyramids, cones, arches, spheres, and so forth. Groupings themselves can create true still lifes—"abstract" shapes are sometimes as interesting as real objects. With the elementary drawing skills we have already, these drawings should be no problem at all.

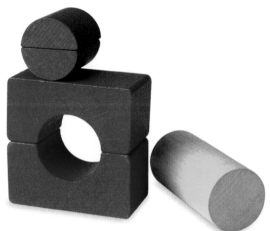

DRAWING
SIMPLE SOLIDS

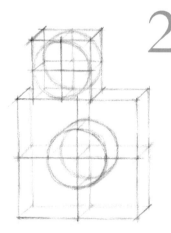

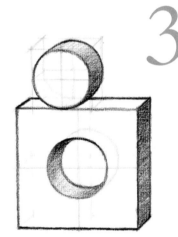

1. To make a geometric sketch of the red and blue forms in the photograph above, draw two squares with a cross in the center as a reference for drawing the circles.

2. Drawing the circles is easy, based on the cross of the horizontal and vertical lines. To add volume, draw diagonal lines that project the figures in perspective.

3. Finally, go over the contour lines and darken the sides of each figure to put them into relief.

The Process of Drawing
These drawings can be made on graph paper, but by this point you should have the skills to draw on regular drawing paper without a grid. First, draw the contour lines, making sure to correctly proportion the size of each element. The circles and ellipses can be drawn before the perpendicular reference lines. To finish the drawing go over all visible lines with more energetic strokes and shade some of the surfaces so that the simple solid volume is clearly represented.

1

2

The colored wooden pieces of traditional building blocks are the perfect models for drawing simple solids. The shape and size of the pieces allow for countless different combinations that suggest buildings or other objects.

1. The initial sketch of a figure composed of two cylinders, two discs, a triangular prism, and a horizontal prism. This is an example of the many figures that can be composed using a set of children's building blocks.

2. Here, as in the previous exercise, you can darken the sides of the figure to achieve an optimal representation of its volume.

Drawing pieces of a building block set is an excellent practical exercise, and also a great theme for original and charming still lifes.

The first step before drawing a real object is drawing its box. Since these boxes reflect the shape and size of each object, it is necessary to adapt simple solids to each object in your grouping. This method of preparation ensures that the proportion and position of each element is correct before you add its contours. The drawing that results is called a *geometric sketch*.

The GEOMETRIC
SKETCH

Process of Geometric Sketching

Start with a sketch of the simple solid most suited to the object you wish to draw—a hexahedron, cylinder, pyramid, cone, etc. Its limits and dimensions should correspond to those of the object you intend to "box in." Continue to approximate the contours of the object inside as if it were wrapped in paper or cloth. You can't see its details, but you can make out its generic shape. Once done with this approximation, you can fill in the details of the object with the certainty that all of its global dimensions will be properly rendered.

Look for a box that matches the dimensions of the object, as if you were wrapping a present. The simplest box is a hexahedron, as seen here.

Once out of the box, the present is wrapped in paper. We can make out its general shape, but not its exact appearance. This general shape is an approximation of its actual contours based on the first geometric sketch.

The General Geometric Sketch

When you're drawing several objects grouped closely to one another, use a geometric sketch that encompasses them all. These sketches can be based on groupings of hexahedrons or other regular shapes. The closer the general geometric sketch gets to the formal characteristics of the object grouping, the easier it will be to render the objects accurately.

The geometric sketch is a first step that many artists skip in order to attack the drawing intuitively. But it is not a good idea to neglect this first step if you want to get good results.

Once the present is unwrapped, the surprise appears: you can render the object as it really is by simply adding more precision to the earlier, approximate shape.

The finished drawing shows the benefits of the basic process of geometric sketching in drawing still life. The additions to the drawing are minor in comparison and can easily be mastered with practice.

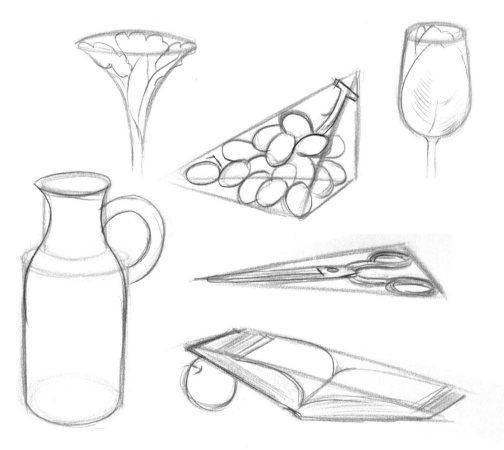

Some examples of simple object sketches aided by sketches of regular geometric bodies. Once we are comfortable drawing basic solids, geometric sketches are no problem at all.

GEOMETRIC SKETCHING *of* SIMPLE OBJECTS

In general, one or two shapes are sufficient to create a geometric sketch of any simple object, such as a flowerpot, teapot, fruit, and so forth. Cylinders and ovals are the most frequently used shapes. The important thing, beyond the choice of shape used, is that the sketch be accurate and not show any deformities, because these defects will show up in the final drawing. Likewise, correct proportions in the dimensions of the geometric sketch—the relationship of its height to its width—is a decisive factor in the accuracy of the final work.

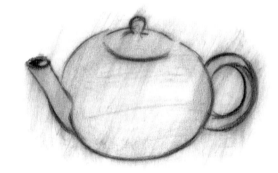

The shape of some objects is barely distinguishable from that of the underlying geometric sketch. All one needs to draw this teapot is a pair of well-proportioned ovals. The rest practically draws itself.

A cylinder and a cone are enough to make a geometric sketch of a potted plant. Here we have drawn both figures with the head of a charcoal pencil laid flat against the paper.

Using the thick lines of the geometric sketch as a guide, we use a soft pencil to draw the actual contours of the plant with the certainty that we are working with the right proportions and a correctly defined shape.

Rubbing a cloth on the charcoal pencil lines of the sketch leaves the soft pencil exposed (these are more difficult to blend or fade than charcoal).

Geometric Sketching wth Charcoal Pencil

One of the most effective methods for geometric sketching is using charcoal pencil. By applying the point of a charcoal pencil flat to the paper, we get thick strokes, which are much easier to control than a thin pencil line. Once the geometric sketch is done, you can use a soft pencil or a Conte charcoal pencil to precisely fill in the contours of the object, drawing over the charcoal strokes. If you then rub a cotton cloth over the entire drawing, the fine lines of the pencil remain and the charcoal strokes fade.

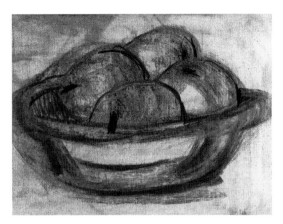

The geometric sketch is the step prior to the proper drawing, but many experienced artists prefer its "sketchy" look to the conventional finish with all the trimmings. The initial sketch is undoubtedly fresher.

The charcoal-based geometric sketch method is simple and direct and provides a certain energy that allows you to work freely on the lines.

Charcoal strokes can be erased by rubbing a cotton cloth over them.

GEOMETRIC SKETCHING
OF COMPOUND OBJECTS

2

When the object you want to draw has a complex shape, the geometric sketch will consist of an assemblage of forms that depart from the essential order of the real object. The easiest way to to approach this is to first sketch a generic shape that represents the entire "compound object." Then, based on this shape, sketch the partial shapes individually where they overlap or come together. The greater the variety we incorporate into these secondary sketches, the easier it will be to accommodate the contours of the object we are drawing.

Geometric Sketch of Flowers in a Vase

One of the most complex—and common—subjects in still life drawing is a bouquet of flowers in a vase. The geometric sketch consists of a compact image formed by several different units. It is not a good idea to make geometric sketches of each of these units, which could turn out to be as difficult, or even harder, than the actual drawing. The way to proceed is to start with a simple form that captures the entire object. An inverted pyramid or triangle is usually the best shape suited to the flowers. Within its lines, you'll add smaller geometric sketches that correspond to its flowers, leaves, and stems.

1. No matter how complex the subject, the initial geometric sketch should be as simple as possible. A bouquet of flowers in a vase can be sketched as an inverted triangle atop a cylinder.

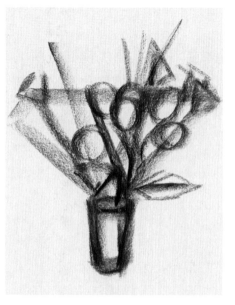

2. Drawing straight lines and ovals within the primary sketch gives us the flowers and stems. Adjust these to reflect the accurate dimensions and volume of each element.

3

3. Once all the principal shapes have been rendered in the geometric sketch, draw the contours, adjusting the lines to match what we see in our model. These lines, made in soft pencil or hard charcoal stick, will not be affected by our subsequent erasures.

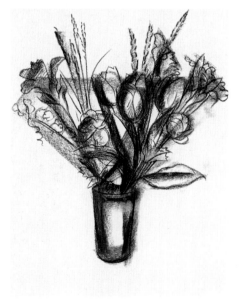

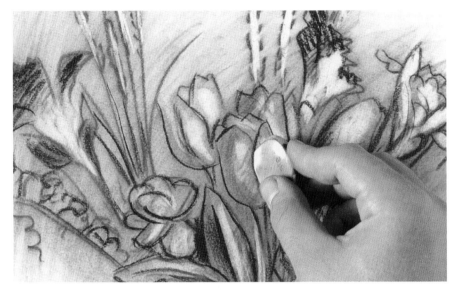

The geometric sketch always establishes the general shape and composition of the drawing. It is the first and most important step in the creation of a still life.

4

4. Once erased, the geometric sketches you made in soft charcoal leave the paper covered in a gray veil that can leave the finished drawing looking very dark. In this exercise, you'll modify that effect by erasing the darkest, more confusing parts to establish the clarity of the subject.

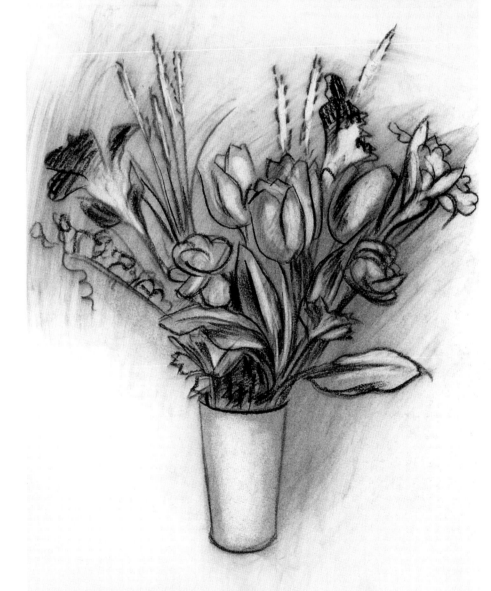

5

5. The finished drawing, after rubbing it with a cloth. The result appears far more elaborate than it actually is because the charcoal provides interesting and convincing shading.

Light

AND

Shadow

IN THE STILL LIFE

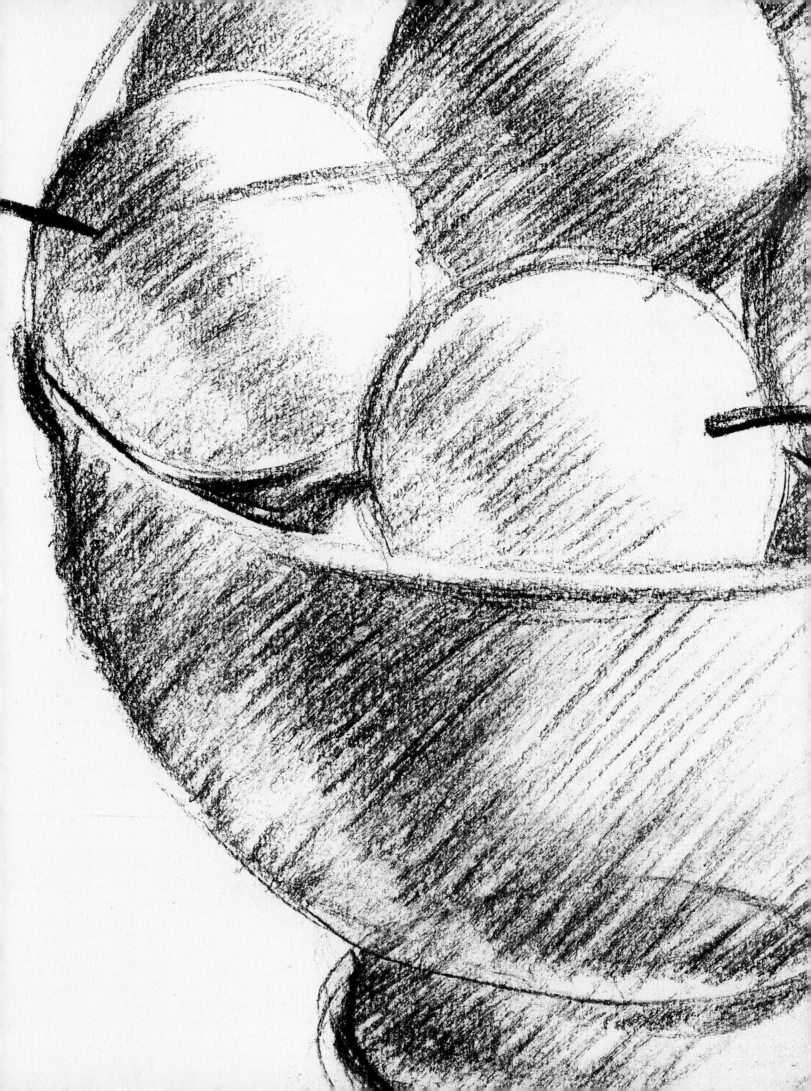

GENERAL

Shading

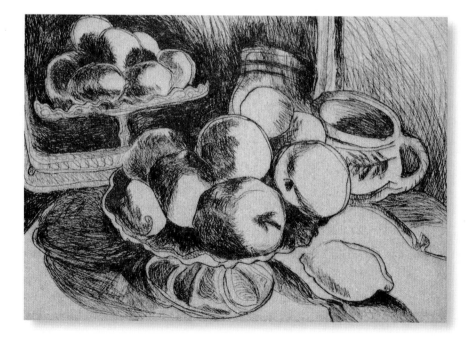

ESTHER OLIVÉ. *CUPBOARD AND MIRROR*, 2000. ETCHING.

Principles

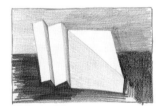

The artist uses light and shadow to organize the forms in a still life within space. Perspective plays another key role in representation, but as we have seen, perspective in still life is a quick, abbreviated process in the sketching of each individual object. Shading, on the other hand, affects all objects and the composition as a whole, bringing a unity and coherence to the work. We will study shading step by step, starting from very simple applications and progressing to treatments that pave the way to chiaroscuro in still life.

SHADING *to* EMPHASIZE
THE CONTOUR OF OBJECTS

In its most basic form, shading is nothing more than an emphasis on a line. If you ignore for a moment the real-world effect of light upon objects, you'll see that a simple thickening of the line is enough to emphasize the sense of light. In the illustrations on this page, we have taken a line drawing and cut along one of its lines with a craft knife. Then we slightly fold the drawing so that the underlying contour is hidden and the fold appears to be shaded. Note that the same effect is achieved by making one of the contour lines of the drawing thicker.

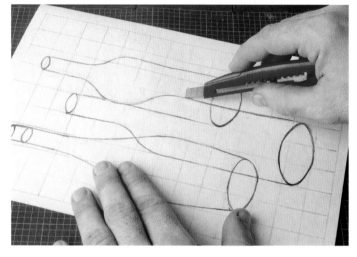

Make a cut along a silhouette in a line drawing with a craft knife and then lightly fold the paper over.

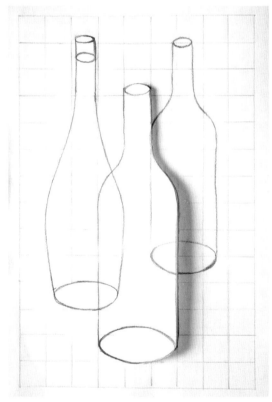

If you fold the paper upward, the shadow appears to affect the back of the bottle, emphasizing its entire contour.

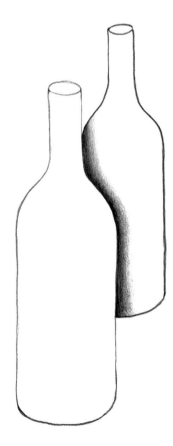

Reproduce this effect by applying pencil to the outer edges of the bottle to create a very dark shadow.

Representing Volume

The illusion of light and volume can be accomplished by shading. With shading, we not only preserve the linear integrity of the composition but create the illusion of three-dimensionality, which is the basic objective of all shading. Therefore, this method applies to the play of light on contour lines of objects that represent volume.

These cutting exercises should be done on medium or large pieces of paper—not thin paper—for maximum effect of folding over the contours. The illusion of volume is created by turning the paper so that light falls on the surface at a very low angle. The shading changes direction depending on whether the paper is folded up or down.

If you fold the paper downward, the low-angle light produces the illusion of volume and the bottle appears shaded.

The illusion of volume is represented here by shading inside the line of the bottle's silhouette in pencil.

Any line drawing can be transformed into a volumetric drawing if you go to work on some of its contours.

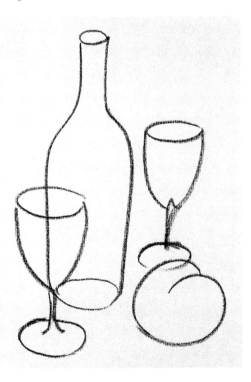

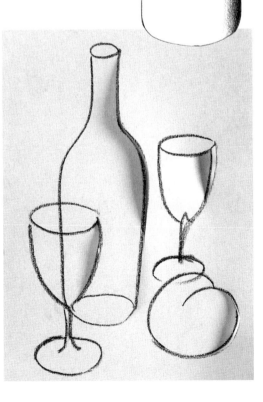

(The cut paper is folded upward for this play of light.) Study the effect of shading by cutting and folding several of the drawing's contours, then replicate the shading in pencil in a new drawing.

The BASIC SHADING
PROCESS

The essence of shading is accentuating certain contours. In two different still lifes here we'll look at methods of shading. The basic drawing must be strictly linear, its silhouettes well defined. Once again we'll be drawing with pictograms, which you have already mastered through practice in the previous exercises. For this exercise in shading, let's imagine that the objects are perfectly transparent and that each of their contours is visible, even if some elements overlap with others. After situating the elements at different heights to indicate their position within the depth of the drawing, let's begin to shade.

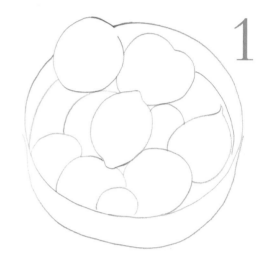

1. The drawing of this fruit bowl is rigorously linear. Every shape is contained within its contours, and the pencil lines are all of the same thickness. The contours limn the characteristic silhouette of each fruit.

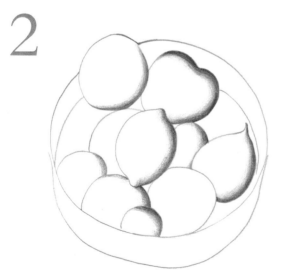

2. Emphasize the contours of each fruit by shading inside its contour lines. The shading should not invade the interior of the shapes, and should be limited to emphasizing the varying volumes by the varying width of the lines.

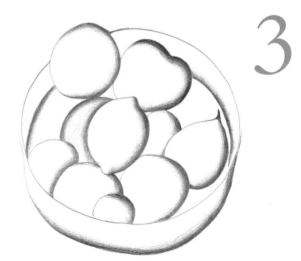

3. With all of the fruits shaded, all that remains to be done is to emphasize the shape of the bowl by shading some of its outer contours as well as the inner contour that describes its bottom. The result is one of light and harmony: each of the fruits stands out, but all within a perfect unity.

Logic and Creativity

The logic that governs this method of shading is simple: all of the shadows are situated on the same side, because they emanate from a single light source. Once you make this lighting decision, you can apply your own sense of taste and creativity when emphasizing the contours of your drawing, applying equal shading or shading some objects more than others. The need for realism is not pressing here because our objective is to arrive at a grouping that looks lighted, and a still life that is aesthetically appealing.

The subject of this still life is similar to that of the exercise below. The elements are practically the same, only here a more conventional method of shading is used. The difference affects the general atmosphere of the drawing and creates a greater illusion of depth.

1. This second exercise consists of a grouping of different objects at different heights. Each element is drawn as a simple pictogram.

2. Even though all the silhouettes are clearly visible, to emphasize the spatial relationships it is necessary to shade a few lines. To make the drawing more appealing, darken the inside of the cup to represent the coffee inside it.

3. Take advantage of the paneled design of the coffeepot to add more shadows to its surface, thereby adding more variety and verisimilitude to the drawing. It is interesting to note that the shading of the wineglass stops at the outer contour line of the bottle. This technique emphasizes the transparency of the glass.

4. Even though we could add more shadow to other contours in the final result, it is not a good idea to overload the composition with too many shadows since we want to preserve the linear integrity of the drawing.

TONAL VALUES *in*
SHADING

When referring to light and shadow, several terms are commonly used, such as gradation, intensity, and tone. All make reference to the the distinct appearance of light and shadow in a drawing, in which some sides of an object are lighter and others are darker. To avoid any confusion, we will use only one term, "tonal value," even though a shaded drawing is composed of different tonal values, each representing different degrees of light or shadow. In theory, these values are monochromatic, no matter what drawing technique we use—pencil, pastels, or charcoal. The more a subject is shaded, the greater the "distance" will be between black and white—in other words, the greater the number of different tonal values it will contain.

A sheet of paper with different folds is an ideal model for studying the effect of shading upon flat surfaces. The edges mark the boundaries between surfaces with different tonal values.

This line drawing of the sheet of paper is extremely simple to create: all it requires is a closing of the outer contours and an indication, achieved by a few straight lines, of the position of the edges created by its folds.

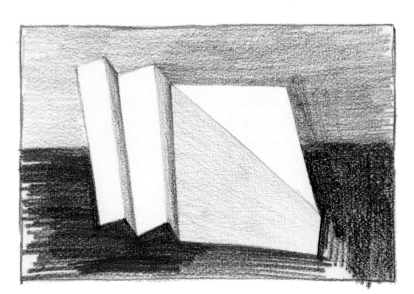

The finished drawing displays a simple distribution of tonal values in pencil. The white of the paper represents the highest contrast among the tonal values, while the darkening in pencil represents black.

This sheet of paper, folded many times over accordion-style and incrementally shaded from one end to the other, illustrates a gradation of tonal values from pure white to absolute black. Shading is a matter of grading and balancing these tonal values within a drawing.

Using a soft pencil it is possible to achieve a complete scale of tonal values because varying pressure on the point allows you to make very light tones as well as very deep, dark shadows. (A)

Burnt sienna pastel cannot produce a black shade, but it can be used to create its equivalent: a deep terra-cotta tone that functions as the darkest tonal value for burnt sienna. (B)

Charcoal emphasizes the darkest tonal values, which have a slightly velvety, matte effect. The lighter tonal values are quite delicate and somewhat harder to achieve. Charcoal strokes always bring out the grain of the paper. (C)

A stumping pencil or "stump" is an instrument that allows one to spread, unify, and reduce the density of shadings in charcoal strokes. It is especially useful for obtaining lighter tonal values from darker stains. (D)

Shading in ink and fountain pen requires hatching or crosshatching. These hatched lines appear darker or lighter depending on the density of the lines. The scale of tonal values can be quite broad, but hatching requires a great deal of patience on the part of the artist. (E)

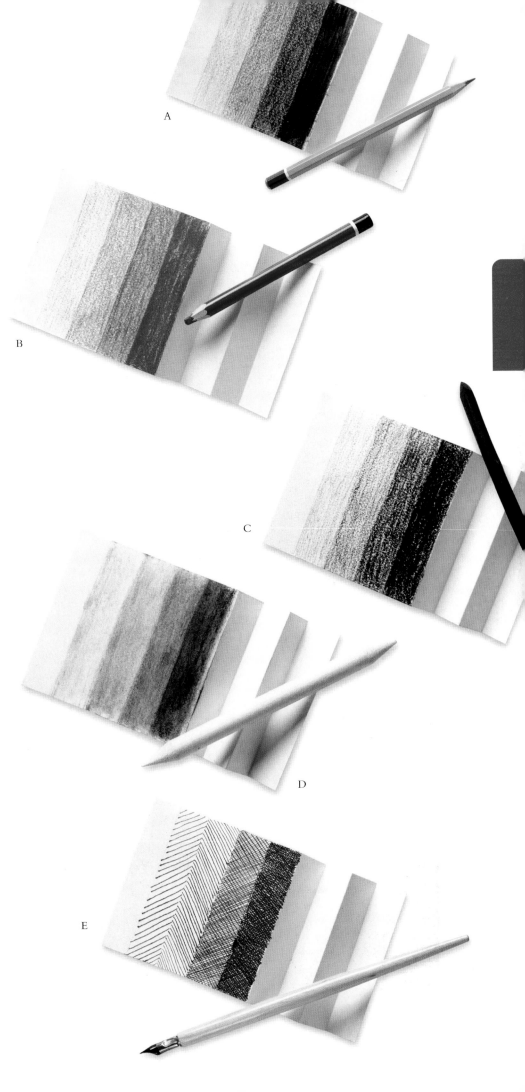

SHADING

FLAT SURFACES

Different types of drawing paper allow you to practice the shading of surfaces. The surfaces in this drawing do not contain any volume, but the shading process will still be based on the principle of tonal values.

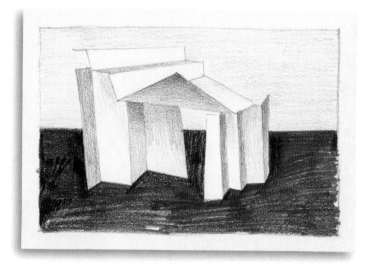

Each edge divides two different tonal values, which are darker or lighter depending on their orientation with respect to the light source. The projected shadows darken the parts of the structure that are less exposed to the light source.

Shading objects with flat surfaces creates an immediate representation of their volume. To shade solid blocks we assign a tonal value to each side of the object, in exactly the same manner we saw in the preceding pages. The tonal value of the shading is determined by the amount of light the surface receives. The edges clearly separate each of these tonal values and determine the sequence of the objects in the finished work.

Inner Shadows and Projected Shadows

Inner shadows correspond to the effect of lighting on different parts of the object. The lighted sides have a light tonal value while the hidden sides have darker values. *Projected shadows* are the shadows that the object casts upon neighboring surfaces and tend to be darker. Here we begin by shading the lighter tonal values and then move toward tones of greater intensity, otherwise the balance will tip toward a very dark spectrum and the effect of lighting will prove unconvincing.

1

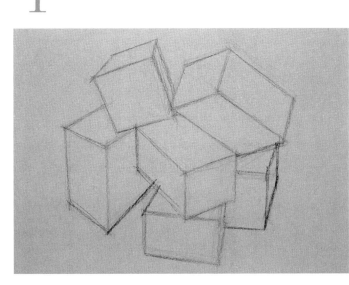

White Pastels

A stick of white pastel provides the whites we need when working on gray paper, as in this exercise. The cold white tone pastel provides works well with any drawing in charcoal. Aside from providing an absolute white, the pastel also allows us to create different grades of gray if we layer it on softer tonal values created in charcoal.

1. The subject of this exercise is a pile of stone blocks, which are drawn in the same manner as the wooden hexahedrons we saw in an earlier section. These are regular shapes whose sides are differently exposed to the light.

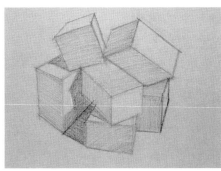

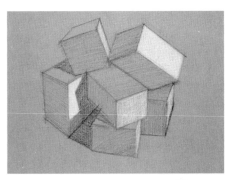

2. Notice how in this first shading the tonal values of the shadows on the dimly lighted sides are lighter than those of the shadows projected by some of the blocks on neighboring surfaces.

3. White pastel allows you to accentuate the lighter tonal values when you work on colored surfaces such as this gray paper. The contrast of the lighter tonal value creates a distinct sense of volume.

2

3

4. Here we can distinguish five different tonal values, from the pure white of the sides that are directly exposed to the light to the dark gray projected on the ground, and in between, the somewhat lighter grays of the shadows projected on other surfaces.

4

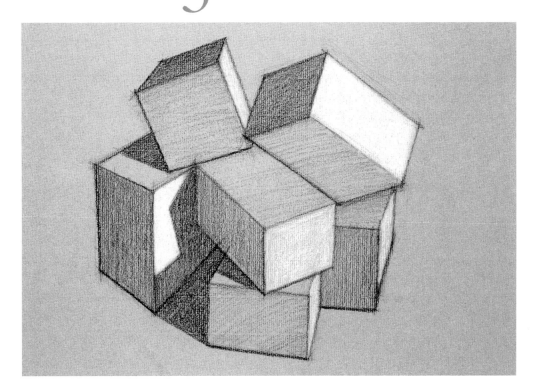

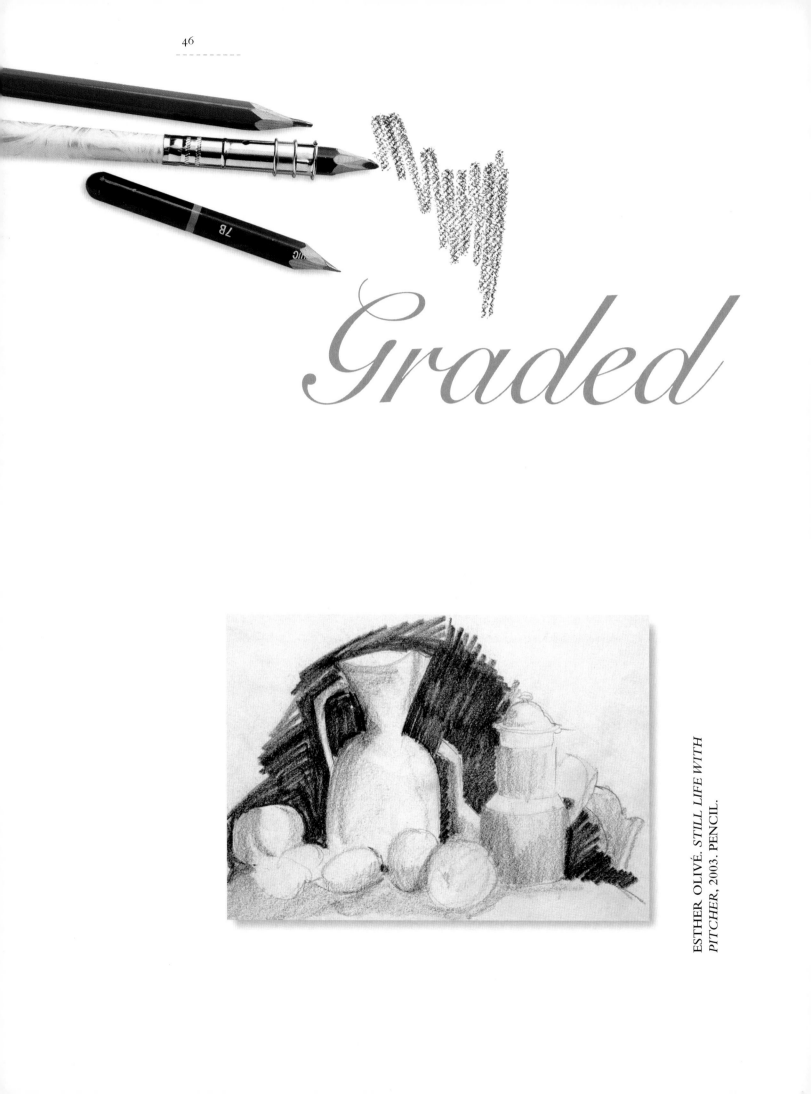

Graded

Shadows
IN THE STILL LIFE

*L*ight and shadow: these two words express a single reality—the effect of light upon objects. Shadows, too, contain light, although a reduced, almost unnoticeable light. Since light and shadow are part of the same concept, the artist uses fading and gradation techniques to represent them, mixing and combining tonal values and blending them in a single continuum. The passage from light to shadow must be represented with a view toward smooth transitions, employing the techniques explained in the following pages.

When we shade flat surfaces we evaluate the tones of areas that are enclosed by their edges. Each value is clearly defined and confined to its location. However, with curved surfaces, in which there are no edges, the tonal values are successively layered and boundaries are blurred. The term for this smooth, continuous transition from lighter to darker values is "gradation." Gradation, fading, stumping, blending—all refer to the process of shading a drawing using smooth transitions.

SHADING
CURVED SURFACES

A simple example of a curved surface. The piece of paper is rolled into itself and held together with a clothespin. The low-angle side lighting accentuates the gradation of tonal values in the shape's light and shadow.

1

2

3

1. The initial drawing can be summarized by the juxtaposition of a rectangle and a section of a conical figure. You are already familiar with the drawing of these shapes from earlier exercises.

2. Using a charcoal pencil, accentuate the first tonal values using a light crosshatch, applying greater pressure on the tip of the pencil where the shadows in the model are more intense: on the exterior of the cone and in the inner side that is exposed to the light. The other strokes should be soft.

3. Finally, blend and fade the strokes using a piece of cotton to achieve a smooth transition from light to shadow. It may be useful to go over the more darkly shaded areas with a new application of strokes.

Tonal Values and Gradation

Grading a shadow means reducing its tonal value in order to represent the smooth passage from light to shadow or vice versa. This can be done with any drawing medium. Some allow gradation through fading, but some do not. Charcoal pencil and hard pastels, for instance, allow you to fade the strokes with your hand or with a cloth. Pencil or ink, meanwhile, cannot be faded and require that the artist make gradations by increasing or reducing the pressure applied to the drawing instrument, or by tightening or lightening the strokes that produce the tonal values of its shadows.

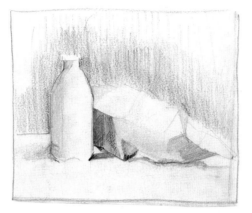

Arrangements containing cylindrical objects provide an opportunity to express the wide gamut of tonalities in a curved surface, as demonstrated by this delicate drawing.

Drawing pitchers, jugs, and other rounded, paunchy objects is a special case in cylinder drawing. Take your time in working on gradations that incorporate the play of light and shadow suggested by these forms.

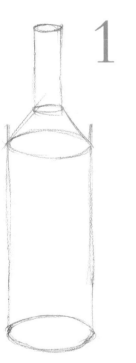

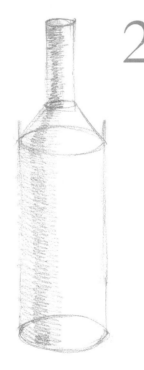

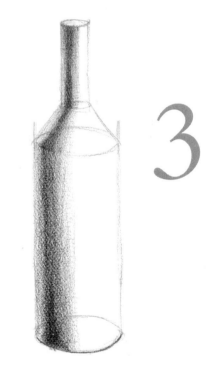

1. The shading of curved surfaces on common objects such as bottles or other containers is easily applied, as long as the surface is opaque. This geometric sketch of a bottle is a larger cylinder crowned with a smaller one.

2. Light pencil strokes indicate the darkest part of the two cylinders. Keep in mind that cylinders, spheres, and other curved surfaces receive reflections of light beyond what is visible, which means that the shadow generally does not cover the side that is less exposed to the light.

3. To finish, go over the shading of the bottle again in pencil, respecting the limits of light in order to accurately represent the reflection the bottle receives from the table or other neighboring surfaces. This final gradation creates a fuller illusion of roundness.

SHADING SPHERICAL
OBJECTS

Fruits are a popular subject in the still life. Their more or less spherical shapes can be shaded easily by observing how this shape responds to light. In most cases, the most lighted part of a sphere will be its upper half, and its lightest tonal value somewhere in the middle. The same can be said of its shadows (on the side opposite the light): they do not appear along the inner boundaries, but in its central area. Between this point and the limits of the sphere there tends to appear an intermediate tonal value, produced by the reflection of the surface on which the sphere rests. To summarize: shading the central part of the sphere, one achieves an accurate representation of its volume and relief.

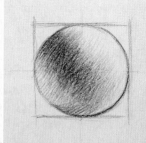

A square with a cross through its center is a precise reference for drawing the initial circle of the bowl. After this it becomes a matter of shading the proper tones so that the curved surface appears smooth.

The darkest part of the sphere is close to its center, where the lines of the cross intersect. By darkening this part, the volume of the sphere appears to move outward, toward the viewer. The rest of the surface is divided among the lightest tone, in the upper part of the sphere, and an intermediate tone in its bottom half.

1

1. This subject, which will be a bowl of plums, is made up of multiple spheres. The geometric sketch, of a perfect circle, provides the size and shape of the bowl. Two ellipses of different sizes mark the position of the mouth and base of the container.

2

The Process of Shading
A mark at the midpoint of each of the sides of a square make excellent reference points for drawing the contours of a circle. The relative difficulty of shading contours can be lessened by making small changes as you progress. Darken each tone little by little until you arrive at a convincing modeling of the surface.

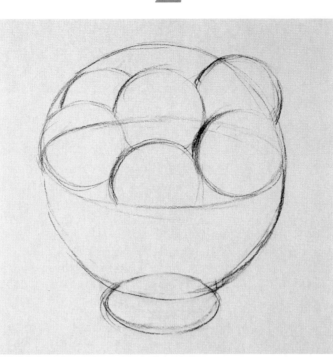

2. This is a drawing of basic contours, similar to a geometric sketch—circles from which we will produce spheres. Draw all of the plums the same size to preserve the general cohesiveness of the composition.

3

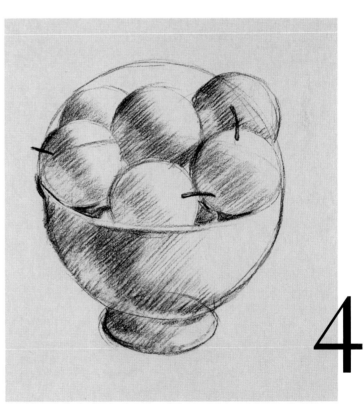

4

3. Shade each plum just as you shaded the sphere in the previous exercise. The area with the darkest tones is in the center of each plum as well as on the bowl itself. In order to achieve a convincing effect of volume, make sure to shade both.

4. The quality of the shading of each sphere and the bowl is clearly visible here. So is the presence of projected shadows, which are always darker than the darkest tone of an object's inner shadows.

BASIC MODELING *for*
CURVED AND SPHERICAL SHAPES

The object of all shading is to create an illusion of three-dimensionality. Descriptive shading is sometimes referred to as modeling. In the case of objects with curved surfaces, modeling provides a convincing sense of the object's solidity. With a single, unidirectional light source, this shading consists of darkening those surfaces opposite the path of light and avoiding a clear division of the borders between light and shadow. On the opposite page a group of spheres is shown inside a container whose curved interior is itself an amplification of each of the smaller surfaces.

Bowls, jars, and pitchers can be interpreted as spherical objects with descriptive shading. This line drawing is the basis for the modeling of a pitcher full of flowers.

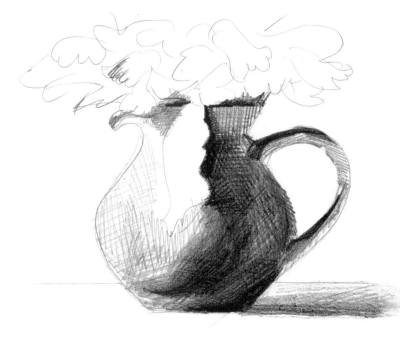

This descriptive shading was achieved by crosshatching with pencil strokes of greater or lesser density. It is interesting to study the changes in the intensity of the shadows, and how richly they nuance the luminosity within them.

Simple Contours and Parallel Strokes

Complex contours or concentrating too much on the line and details of the initial drawing can make the process of shading awkward. The initial drawing should be as simple as possible, as shown at the start of this exercise. Shading is created using parallel strokes that grow tighter and denser in the darker areas of the drawing. It is important for these strokes to be oriented toward the light so that the border between light and shadow does not appear to have a distinct dividing line.

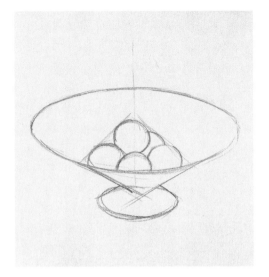

The subject consists of a set of spheres (plums or similarly shaped fruits) inside a conical container. All of these shapes are curved and must be represented by the simplest of circles or ellipses.

Shade oval shapes in the same manner as you do spheres. When the subject is a grouping of many of these shapes (as in this basket of eggs), the shading can be lighter and may consist of a darkening of one of the pieces, leaving the rest as simple drawings.

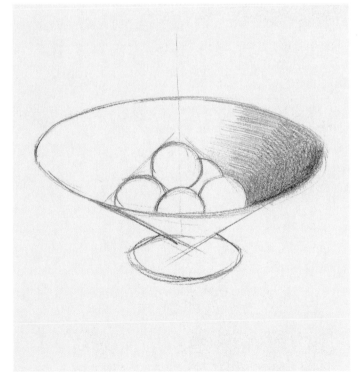

The inner shading of the fruit bowl accentuates the shape of the spheres inside. This indirect modeling method is well suited to the representation of curved bodies. Shadows are created from parallel strokes that mimic the curve of the bowl, and rendered in charcoal pencil.

Render the shading of each fruit by taking into account the darkest areas that are found toward the center. One of the fruits is almost completely dark from projected shadows, but the area closest to the surface of the bowl is lighter on account of the reflection from the dark piece.

SHADING *and the*
PLANES OF LIGHT AND SHADOW

A grouping of objects never represents an ordered series of flat and curved surfaces. Instead we see a set of very different surfaces, each of which takes in light differently and is affected by the shadows and reflections from other surfaces. To approach shading without getting confused about these nuances, we define the planes of the drawing—that is, find the edges that naturally divide light from shadow.

This drawing of a banana contains an inner line that divides its surface into two planes, each of which takes in light differently. Here the natural shape of the fruit suggests that division.

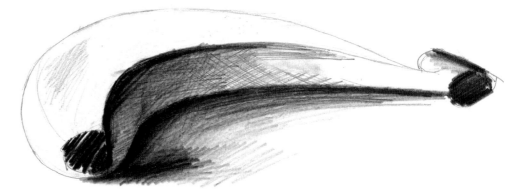

Taking advantage of the natural shape of the fruit, we can emphasize the shadows on the plane away from the light, making sure to gradually lighten this shadow until it disappears into a lighted plane.

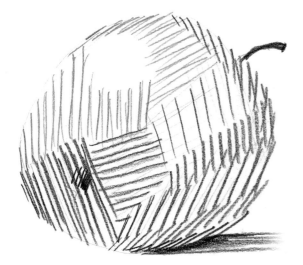

Any shape can be considered as an aggregate of planes of light and shadow. This apple has been divided into distinct facets, expressed by parallel strokes of varying intensity to indicate light and shadow.

Curved Edges and Strokes

The surfaces of fruits generally do not have edges, so light tends to spill all over them without leaving defined borders to separate light from shadow. When beginning the shading process, it is a good idea to work as though those edges were in fact present, so that the planes of light and shadow can be clearly distinguished. Depending on the needs of each drawing, in later stages you can always soften abrupt changes in shading. This way of working is particularly well suited to shading techniques based on an accumulation of strokes (graphite pencil, markers, fountain pen, etc.).

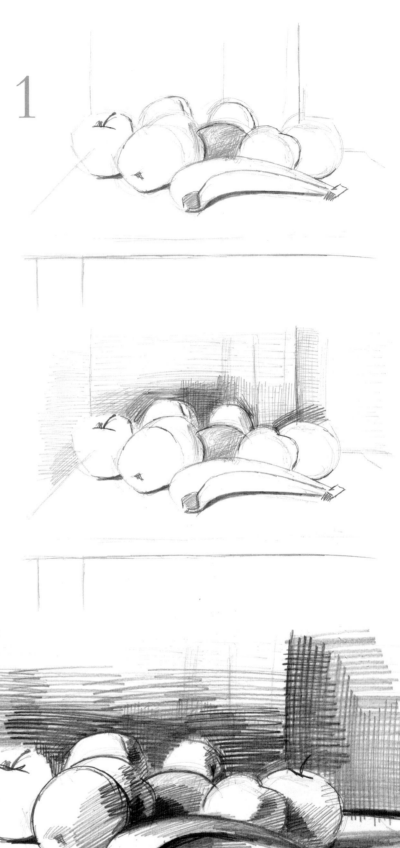

1. In an informal grouping of fruits, it doesn't make sense to distinguish between the defined planes immediately because most fruits have a more or less spherical curved surface. In shading, however, you can interpret the entire grouping as an aggregate of planes.

2. Different pencil strokes accentuate different planes of light and shadow. The shading of the background is the "negative" of the grouping –and serves to accentuate the fruits.

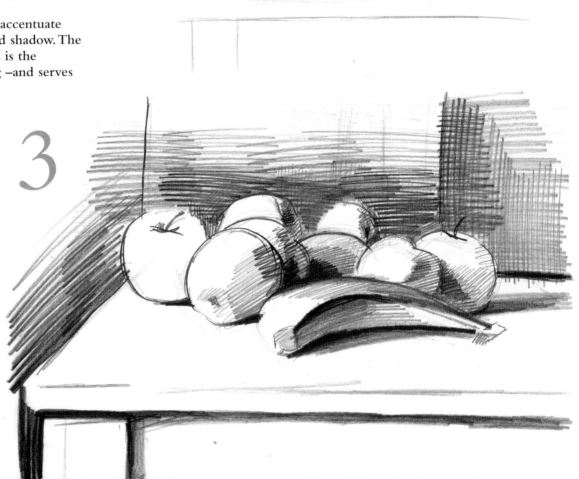

3. The few shadows on the fruits themselves are based on a clear distinction between darker and lighter planes, which together with the energetic shading of the background completes the drawing. There is no need to emphasize the gradation of each fruit.

SHADING *and the*
DIFFERENT TONAL VALUES OF OBJECTS

The process of shading establishes the tonal value of each object. Shadows will have a different appearance when they fall on a light-colored object than when they fall on a darker one. In practical terms, this tonal valuation is the result of a process that starts with a general neutral shading, independent of the tonal value of each element. It is during the second phase, in the final distribution of tones, that the surfaces are darkened to a more sober tonality and the drawing is accomplished.

The Distinction of Tonal Values
As you begin shading, consider all of the objects in your subject that have a similar tonal value without their color. It is sufficient in this phase to use simple shading to indicate the direction of the light and the basic play of shadows. Only in the second phase do you distinguish the tonal value of each of the elements by darkening the surfaces with a darker or more intense color.

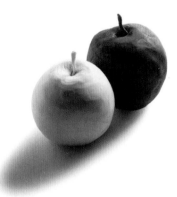

1. The beginning drawing does not take into account the tone of each apple. Instead, treat both elements as roughly spherical forms exposed to light.

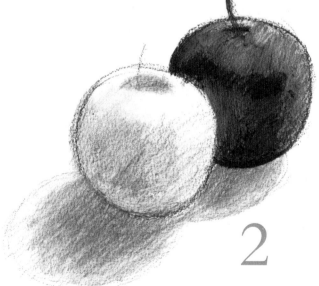

2. One of the spheres has been darkened by adding charcoal strokes until it is nearly black. But nuances appear within that darkness: the areas that are most exposed to the light have been treated with a stumping pencil, spreading the stain of the charcoal until its tone is lightened.

3. The shading of the light-colored apple is far more delicate. It consists of a few light strokes in charcoal. It is the same treatment that has been applied to the shadows cast by both fruits.

Equalization and Differentiation of Tonal Values

The differentiation of darker and lighter tonal values depending on the color of each object is optional. The artist decides whether to contrast tonalities or whether to equalize the light and shadow in the still life. In the former case, representation becomes more dense and compact, with a greater suggestion of volume; in the latter, the result is more atmospheric, light and impressionistic. Each approach functions according to the artist's personal taste. In theory, the method of differentiation of tonalities is more realistic than equalization, but in terms of results, the two methods are equally convincing.

Starting with a single subject and arrangement, you can take different routes with respect to tonal treatment in the drawing of a still life, as evidenced by the two results reproduced below.

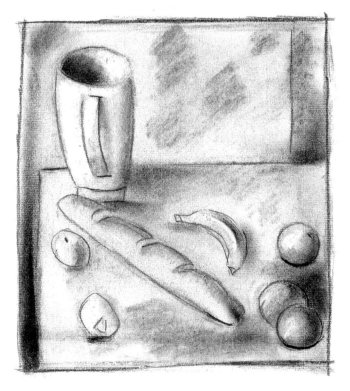

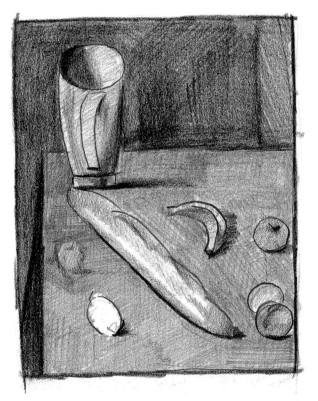

This result shows a tonal equalization of all the objects, giving each a light shading within the same scale of tonal values.

By differentiating degrees of light and shadow between surfaces, the composition becomes denser and more compact. It is not as airy or atmospheric as the previous drawing.

METHODS *of* TONAL
VALUATION AND SHADING

Tonal valuation and shading are directly related to the method used to create them. The process will vary depending on the materials you use, as will the result. Each artist develops preferences with respect to the materials he or she chooses to work with. Some prefer thin stroke techniques based primarily on line (using pencil or pen, for instance), while others lean toward more pictorial techniques that focus on the charcoal stain, pastels, or brushes. Each of these techniques confers a particular character on the finished drawing.

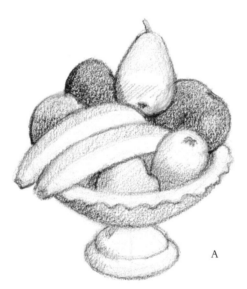

A

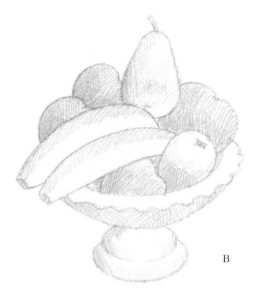

B

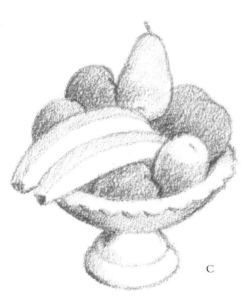

C

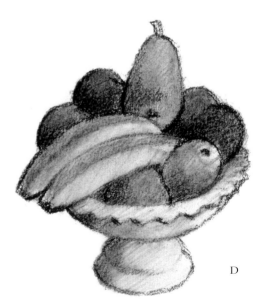

D

Light and Dark Techniques

The degree of contrast in shading depends on the chosen technique. Shadings in pencil, particularly if one uses a hard lead, facilitate a smooth transition between tones but can never produce powerful contrasts—that is the province of charcoal or India ink. We can therefore speak of light and dark techniques, keeping in mind that you can compensate for the lower intensity of a light technique through subtle refinement of stroke and gradation. A drawing in ink can bring together the advantages of both techniques: it allows both a refinement of detail and a decisive contrast between light and shadow.

The combination of several techniques can be a good idea if the different media are compatible. At left is a drawing that combines charcoal and burnt sienna pastel. The strokes of each can be blended together up to a point, although it is better not to do so systematically because the results tend to be messy.

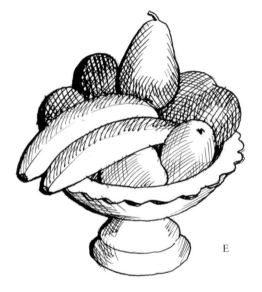

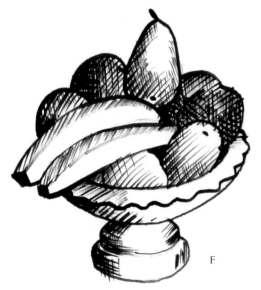

A. Soft graphite pencil is ideal for smaller works that require nuance without forsaking high definition. The most commonly used pencils range from a 2B to a 5B lead.

B. Hard lead pencils allow for an extraordinarily high definition in detail, but the variety of tones it produces is greatly reduced, limited to the lighter end of the spectrum. This finish corresponds to a pencil with a very hard lead (4H).

C. Burnt sienna pastel is the warmest medium in drawing. Its touch and manipulation allow for a considerable tonal range. It is not well suited to smaller works.

D. Charcoal is only used in medium- and large-scale works. It does not allow as much control over its strokes or as high detail as pencil or burnt sienna pastel, but it is an apt technique for subjects dominated by sharp contrasts.

E. Pen lends itself to a highly detailed finish in smaller works. In subjects rich in tonal contrasts, however, it can prove to be a slow and monotonous process because all shadows are created through a meticulous layering of strokes.

F. The stroke of a reed is much thicker and more energetic than that of a pen. Whereas pen requires superimposing many layers of strokes, a reed produces compact spots of ink. Its possibilities for highly detailed works are not equal to those of the pen.

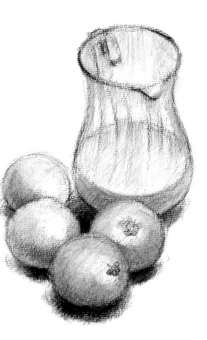

Paper is the most common drawing surface, and there are many different kinds and qualities of paper. Each type of paper yields a particular result that is more or less well suited to the drawing technique. Smooth, satiny paper is best suited to pen and ink and also works well with graphite pencil. On this kind of paper, lines are clean and precise and their contrast against the luminous white of the surface is appealing. Grainy papers are best suited to

SHADING *on*
DIFFERENT DRAWING SURFACES

Charcoal requires textured paper, the surface of which is made up of tiny cavities that trap the charcoal particles. This texture gives drawings an interesting finish and a great intensity in the blacks.

media that produce thick strokes, such as charcoal or pastels. The tiny craters in the texture of high-grain paper collect pigment and allow for energetic, saturated strokes. The more textured the paper, the coarser the treatment of the drawing should be.

Smooth or glossy paper yields good results with graphite pencils. The smoothness of the surface allows for a high degree of detail.

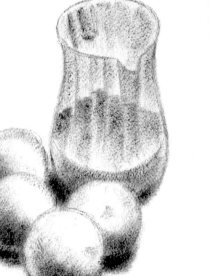

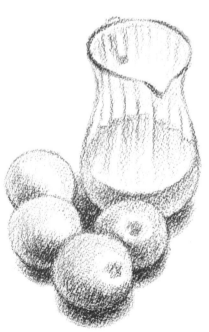

India ink works only on glossy paper and, if using a brush, on papers with a medium grain, using a "dry brush" technique. This consists of applying very little ink to the brush so that it reveals the texture of the paper with each stroke.

A burnt sienna pastel drawing requires a grained paper, which favors the intensity of the natural color of burnt sienna. The paper should not be highly grained, however, or it will diminish detail in the artist's rendering.

Shading on Different Surfaces

Smooth paper provides a delicate, precise finish, while textured paper allows for rougher results. Fading and blending are different for each type of paper: only graphite can be blended or faded on glossy paper, and then only very lightly, whereas many different kinds of fading are possible on textured paper. Ink can never be faded or blended, but a similar effect can be achieved by using a "dry brush" technique—applying brushstrokes with very little ink so that they reveal the grain of the drawing surface.

Colored paper offers a smaller variety of textures, but it is well worth experimenting with for interesting results. The drawing at left was rendered on brown packing paper, using charcoal, burnt sienna pastel, and white chalk. The background color of the paper brings its own contribution to the composition.

The "dry brush" technique is used for drawing in ink. Strokes are applied with very little ink on the brush so that the grain of the paper is visible.

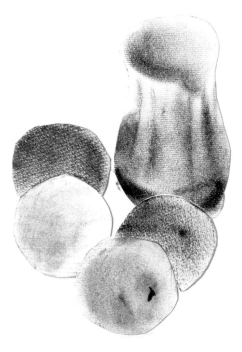

A collage composed of different types of paper for each element of the still life. The drawings were all done in charcoal.

Chiaroscuro

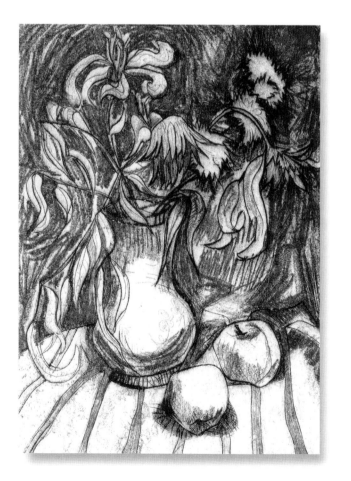

ESTHER OLIVÉ. *FLOWERS AND FRUITS*, 2002. ETCHING.

Techniques

Beyond its distinctive shading and tonal values, chiaroscuro is a visual synthesis that leads drawing to the threshold of painting. Up until now our drawing techniques have been geared toward accentuating objects and their volume, but in chiaroscuro we find a global vision of the still life: the subject as an autonomous work. Chiaroscuro takes into account the entire space within which the subject appears. It implies atmosphere, lighting, and character. It also reveals a style and attitude toward the still life that distinguishes the work as a personal creation that transcends its technical merits.

CHIAROSCURO
USING STUMPING

Stumping is a common technique for achieving atmospheric and visual unity. Tonal values are blended into one another, by hand or a stumping tool, and light and shadow alternate in a continuous, flowing manner. This means putting aside the integrity of the pictogram. Shapes are not discrete, sealed off within themselves; instead, one shape gives way to another, as if they were all submerged within the same luminous liquid. The medium most well suited for this technique is charcoal. Charcoal strokes leave a large quantity of loose particles on the paper that with stumping spread out to create a gradation of grays which can be extended until it fades into the white of the paper.

1. Although we still begin with an outline that is similar to the geometric sketch, in chiaroscuro we approximate the shape, using thick charcoal strokes that indicate only the position and size of each form.

2. Using the same thick charcoal strokes, we add a few details and highlights with a view toward later stumping these strokes, which will completely alter the appearance of these early phases.

The Stumping Process

Stumping is applied to charcoal (or chalk) drawings to establish the initial balance of light and shadow. We use a rolled piece of paper, called a stump, or our fingers to fade and blend the charcoal. After stumping, some of the contours can be outlined, taking care not to close off the lines and leaving open spaces so that the atmospheric unity of chiaroscuro emerges. The stumping process continues as we apply further charcoal strokes in order to fade or blend them immediately afterward. To finish, we can use an eraser to emphasize the most prominent lights in the composition.

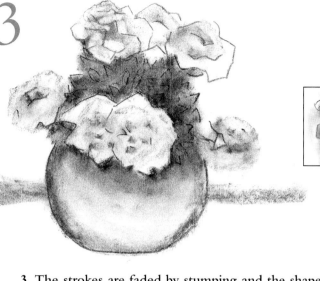

3. The strokes are faded by stumping and the shape of the object is now defined by the lines drawn around the charcoal stains. Some of them will be further faded or erased.

A chiaroscuro achieved by stump work tends to soften outlines and unify all the shapes in a common atmosphere. Adding precise lines helps recover the exact shape of the objects in the picture in a still life drawn in this manner.

A B C D E

A. To achieve darker tones layer new strokes onto the earlier stumpings. The leaves that appear in shadow beneath the flowers were stumped in this way.

B. The background is blended or faded using your fingers or a stumping tool. The stumping is darker or lighter depending on the amount of charcoal on the paper.

C. Traces of faded but still visible charcoal. Stumping enriches the texture of the composition.

D. Sometimes pencil strokes are layered on the faded areas to suggest the background or the leaves and stems of the flowers.

E. Erasures define the light tonality of the flowers, while pencil strokes define their shape.

4. *After new applications of charcoal and more stumping, we further enhance the forms. Chiaroscuro serves to unify the composition.*

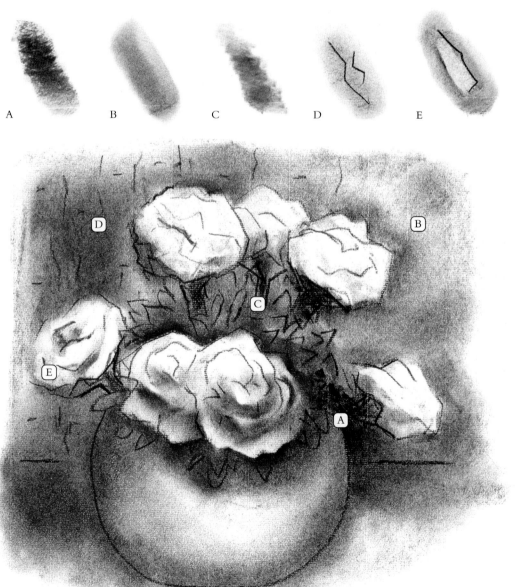

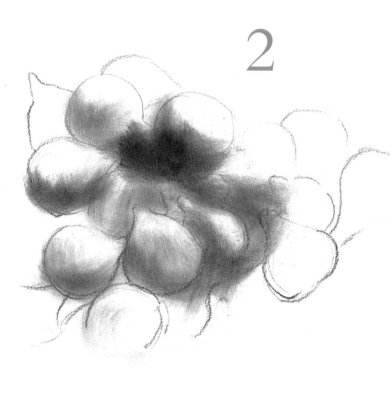

STUMPING *with*
CLOTH OR COTTON

Charcoal allows for energetic shading while preserving the possibilities of detail because it tends to spread out and coat the paper. Its tonal scale, from soft gray to black, is ample and can be extended, faded, and manipulated with a previously stained cloth or piece of cotton. The previous drawing did not enclose the flower forms in precise contours because their final definition depended on the play of light and shadow. Stump work with a cloth or cotton ensures a delicate, silky finish. Shadows created by this method can be nuanced with erasures to highlight lighted areas. The finished drawing should be sprayed with a fixative to keep it from smearing or fading over time.

Saturate a piece of cotton with charcoal that has been rubbed on a separate piece of paper, which can also be used to remove excess particles from the cotton to reduce the stain intensity. Powdered charcoal is also available for this purpose.

1. Preparatory drawing should be kept to a minimum to allow for greater freedom in the light and shadow of the chiaroscuro. These mininimal strokes are sufficient to position and arrange each of the figs in the subject.

2. Begin stumping the drawing directly with a piece of cotton dipped in charcoal powder. Work quickly and freely, without heeding the contours, invading the different fruits with generous passes of the cotton.

1

2

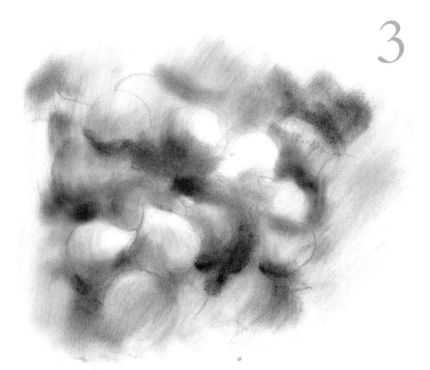

3

Stumping to Fade and Blend

Starting with simple strokes, which should never completely define the outlines, rub charcoal on a separate piece of paper to make a very dense stain. Dip a piece of cotton in this stain until it is saturated with charcoal. Use the cotton as your drawing medium, spreading darker stains of charcoal in the areas where the shadows in your subject are most intense. A second, clean piece of cotton can be used to lighten some of those dark stains. This operation is repeated until you arrive at a pleasing distribution of light and shadow. Finally, an eraser is used to recover the white of the paper in the areas where the light on your subject is brightest.

3. The darkest tones are achieved by applying the charcoal directly. The medium tones are created by applying a clean piece of the cotton to dark tones. An eraser is used to highlight with white and produce the lightest tones.

4. The solidification of the shapes using darker lines and applying an eraser comes once the entire process of tonal valuation and stumping has been completed.

4

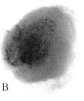

A

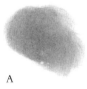

B

C

D

A. Charcoal applied with cotton leaves a subtle trace and no markings. Only the grain of the paper is visible through the veil of gray.

B. To achieve darker grays, add charcoal for nuance to the earlier cotton stains.

C. In the final phase of the drawing, add thin strokes that define and limit the outline of the figs.

D. The eraser allows you to uncover the white of the paper and highlight the brightest parts of the figs.

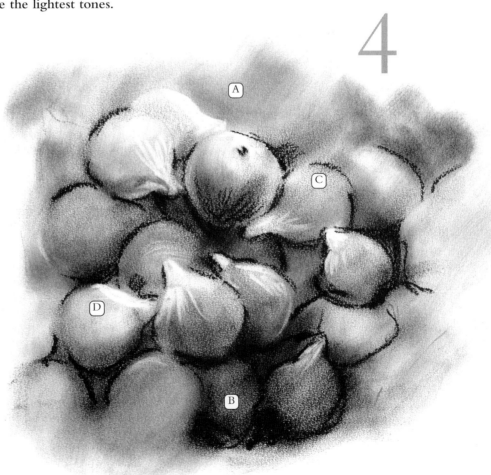

CHIAROSCURO USING
BLOCKS OF SHADING

Just as stumping unifies and blends light and shadow, shading with blocks establishes a clear contrast between light and shadow. Every shaded area in chiaroscuro has its own tonal value, which establishes the exact degree of light on that sector of the composition. This favors the ultimate clarity of the chiaroscuro drawing: outlines appear clearly defined due to the sharply contrasting patterns of light and dark. To succeed as a visually engaging chiaroscuro, the differences in contrast must be strong—differences that are too subtle tend to weaken the final effect.

Simultaneous Contrast

The juxtaposition of blocks of light and shadow in chiaroscuro produces what is known as simultaneous contrast. By applying a darker or lighter tone depending on the neighboring tone—a darker tone when the tone next to it is lighter, and vice versa—the objective is to emphasizes a clear division between contrast in tones. These divisions become virtual lines in the drawing, borders for the shapes represented. The drawing is consequently strengthened by this chiaroscuro technique.

1. With a chiaroscuro technique, this outline drawing of books will become well defined when the borders of the different blocks of light and shadow are emphasized.

2. The preliminary shading of the books foretells that chiaroscuro style is being adopted here: blocks of light and shadow are being juxtaposed to reinforce contrast.

3. The contrasting tonality of the background is produced by applying thick charcoal strokes. This darker tone raises the profile of the entire block made up of the books and emphasizes the lighting centered upon them.

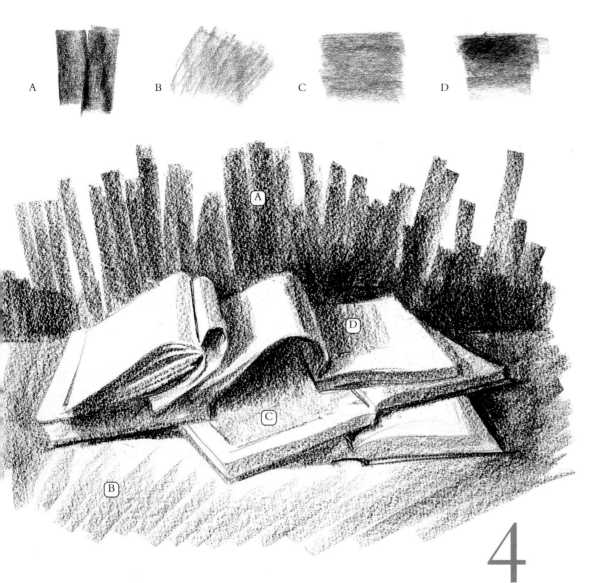

4. A lighter shading serves to create the tone of the plane of the table. This shading completely surrounds the group of books and encloses the finished composition.

A. Wide charcoal strokes are made with the tip of a flat Conté charcoal stick on the paper. Each stroke preserves its shape and length.

B. The softer, less well defined tones are produced by lightly stroking the charcoal on the paper. The shape and size of the strokes are far less visible here.

C. Blocks of uniform tone are achieved by stroking the charcoal in several directions until each stroke loses its individuality.

D. Gradations are produced by adding layers of dark strokes onto soft gray tones. At no point have we faded or blended the charcoal stains.

Shading Blocks of Shadow

Before applying blocks of shadow the initial drawing should be fairly complete so that the borders between the most important tones are established. This doesn't mean that the details should be hurried, but the most significant contours should be represented clearly. The blocks of shadow can be created using any drawing media, but it is always easier to work—if the drawing is in a medium or large format—with media that produce thick strokes, which makes it easier to shade in large areas. This drawing of a fruit bowl was made with a Conté stick, a dense and somewhat oily charcoal crayon that covers a large area and allows you to neatly define the limits of the stain.

In the block technique of shading the outline of each object is reinforced by its juxtaposition to a tone lighter or darker than its own. The result is known as simultaneous contrast (sometimes called "afterimage").

Crosshatching is the standard shading technique for any drawing medium characterized by a fine stroke. Shading in pen, India ink, or pencil, the instrument used for this exercise will always require making a series of parallel lines that intersect—that is, crosshatching. This is a distinctive method for grading tones, since it not only represents a tonal value in the composition, but also gives the drawing a feeling of texture. The combination of multiple hatchings produces works of rich and varied tones, and suggests the real-life quality of the surfaces represented.

CHIAROSCURO EFFECTS *with* CROSSHATCHING

1

1. The initial drawing for a chiaroscuro based on crosshatching should be orderly and minimize specific tonal information. The details will be established in the play of the chiaroscuro.

Tones in Crosshatching

The varying intensities of tones within shadows are determined by the density of the hatched strokes and their direction—in other words, how tight the strokes are and whether they are vertical, horizontal, or diagonal. Each series of hatchings creates a texture that adds a visual value: the darkest shadows are never completely black, and in them one can almost see each one of the strokes; likewise, lights are never entirely white.

2. The first hatchings should be very soft and smooth and cover the broadest areas of the composition, leaving the details and more complicated parts for later.

3. Accents are added to the softest hatchings to bring them into relief and emphasize volume. These darker areas also bring the central subject closer to an advanced plane in the composition.

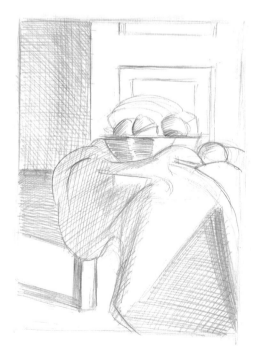

2

3

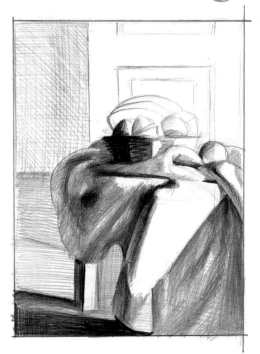

Details in the Shadows

A crosshatched drawing always displays dense textures in the shadows. This creates the illusion that the drawing contains much more visual information—much more detail—than is actually there. This is one of the most appealing aspects of crosshatching: it allows the artist, drawing slowly and carefully, to calculate precisely the tonal value of each light and every shadow.

4. Crosshatching, by darkening each part of the drawing to a different degree, achieves a convincing representation not only of the objects in the chiaroscuro still life but also the objects' positions in the space of the work.

Tones of a chiaroscuro can be inverted without losing the atmospheric feeling of the drawing. The drawing at left leaves the background nearly white and confines the shadows and play of light to the inside of the objects.

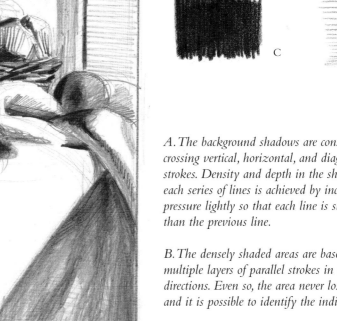

A. The background shadows are constructed from crossing vertical, horizontal, and diagonal pencil strokes. Density and depth in the shadow in each series of lines is achieved by increasing the pressure lightly so that each line is slightly darker than the previous line.

B. The densely shaded areas are based on multiple layers of parallel strokes in different directions. Even so, the area never loses its detail and it is possible to identify the individual lines.

C. The nearly black parts of the drawing are created by tightening the crosshatching so that it is dense and blankets the surface. Here it is impossible to identify individual lines.

D. The lightest areas contain only very soft lines hatched in a single direction.

Shapes, Qualities, AND *Subjects* OF THE STILL LIFE

"*The most meritorious work is that which is most similar to the thing it represents.*"

Leonardo da Vinci (1452–1519)

Transparency,

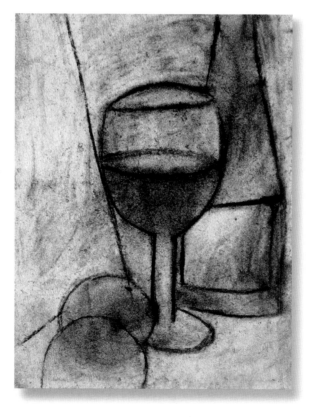

DAVID SANMIGUEL. *WINE GLASS AND MANDARIN ORANGES*, 2003.

Shine, AND Reflections
IN THE STILL LIFE

In general, the variety of contrasts to be found on an object's surface are a predominant factor in the quality of any drawing. Alternating between smooth surfaces, crushed tones, ornamentation, texture, and drawing strokes in different directions—all create striking contrasts. In still life drawing, evoking the consistency or attributes of different materials and their surfaces is essential. Glass and metal appear in many still lifes for this very reason, as they introduce areas of intricate tonal valuation that contrast with smoother surfaces. The representation of these surfaces is often considered a burden by the artist and an added complication, but in the following pages you will learn how to approach these drawing challenges with confidence and ultimate success.

REPRESENTING *an*
OBJECT'S CONSISTENCY

The old masters were virtuosos at representing object surfaces. They went out of their way to choose objects for their still lifes based on the rarity of its surface or the richness of its materials. The public appreciated the stunning realism in these works, and painters would compete with one another to achieve even greater verisimilitude and the sensation that their objects "could almost be touched." Virtuosity is less appreciated in art today, but the artistic value of such accomplishments still remains important.

Mimicking Virtuosity

Virtuosity can at times turn into gratuitous exhibitionism, a display of manual dexterity to the detriment of the imagination. When an artist makes an effort to imitate surfaces without a solid foundation in compositional design and organization,

The real world shows us many different aspects of every object, and the artist must choose among these to express the quality of their surfaces and materials. The final goal is not a total richness of detail, but an impression of the object's aspects that function appropriately within the drawing

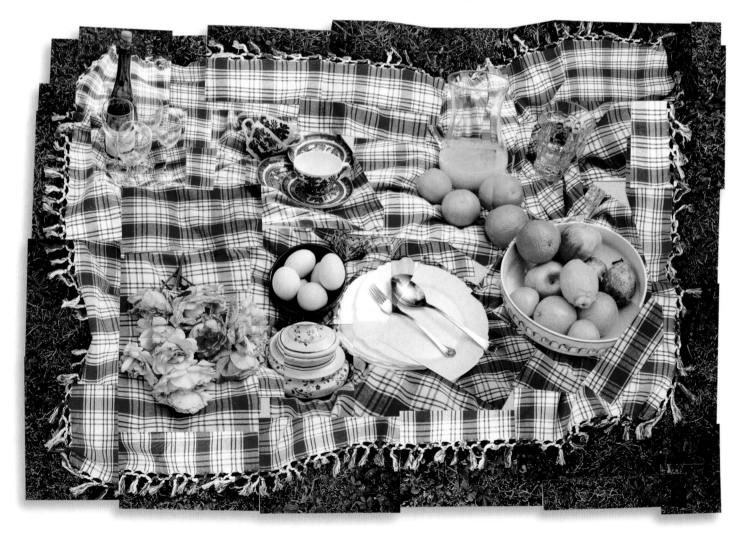

the work does not improve in the slightest. Instead, it becomes a shallow attempt to show off with the pen or pencil, like an exercise in handicrafts. An honest approach to depicting surfaces, on the other hand, is based on the specifics of a drawing, which can be curvaceous or geometric, continuous or discontinuous. The characteristics of the line itself can suffice to awaken in the spectator the idea of a particular material, hard or soft, smooth or creased.

A quick interpretation of these shapes suggests rigidity and materials such as ceramic or wood. The rigid treatment of the tablecloth expresses strength, making a forceful composition.

Flowers can be treated in many different ways, from a highly detailed, elaborate rendering to a freer, more suggestive approach. The important thing is the conviction and graphic appeal of the result.

A drawing can suggest different surfaces, materials, and colors. The artist, however, must have the skills to represent objects properly before attempting any inventive new visual experiments.

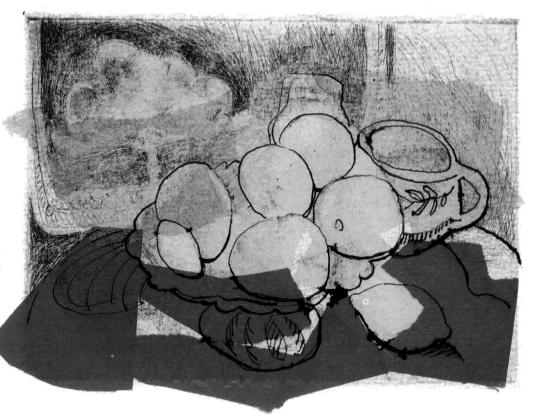

REPRESENTING

TRANSPARENCY

Capturing the transparency of glass when directly drawing a cup, a glass, or a bottle can prove quite difficult without mastery of the graphic fundamentals involved. The illusion of transparency is based on the relationship between light and shadow, or between dark and lighted areas. It also depends on the interposition of one surface against another—for example, water or another background object as seen through glass—and must consist of the pronounced interruption of a tone or gradation in relation to another.

The Background Seen Through Glass

The easiest way to suggest transparency is to draw whatever is behind the glass object, modifying or distorting it the way the glass does. In the case of a cylindrical container, the horizontal lines of the background bend while the vertical lines remain more or less unchanged. Other modifications typical of glass involve the distribution of light and shadow: light appears along the edges of the object and shadows in the center, exactly the opposite of what occurs with an opaque object.

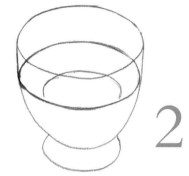

1. The glass bowl's transparency must be approached by disregarding much of the information we receive from the model and keeping only what is strictly necessary for the effect to occur.

2. This concise initial drawing is limited to the contours of the glass and the surface of the water.

3. The shadings advance with total simplicity, as if to represent two superimposed glasses, or one glass encased in another. The result is a simple but convincing effect of transparency.

The shaded dark band in the background is distorted in accordance with the shape of the vase. The tonal values are modified in the inner sides of the container due to the effect of light passing through the glass.

This initial drawing for a vase situated in front of a dark background shows little information as yet about transparency.

Water Through Glass

Water inside a glass pitcher can be represented by bringing greater luminosity to the surface, in contrast to what surrounds it. Since the surface fully faces the light, it should be left completely white while the other areas— the limits of the container as well as the outer edge of the water's surface—are shaded.

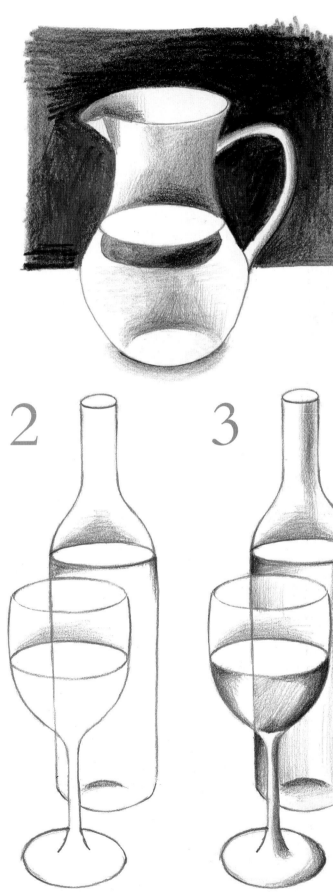

Here two transparencies are combined (the water contained in the pitcher and the pitcher and its background). It is interesting to note the curved reflection of the table on the belly of the jar.

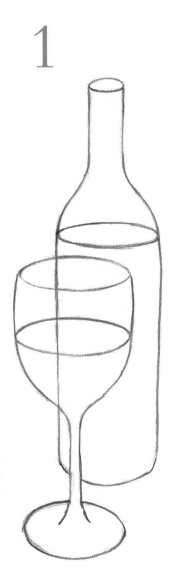

1. A more complex composition, of a clear bottle and goblet containing water, follows the same process for representing transparency.

2. Create shadows starting from the upper limit of the liquid's surface. The shadows especially affect the central part of the goblet and bottle.

3. The rest of the shadows are limited to narrow borders on the sides of the containers. The effect of transparency is now complete.

Once you understand the basic concepts of representing transparency you can begin to create still lifes that include glass objects. Any drawing tool can be used for this purpose, but graphite or colored pencils are the easiest with which to control the effects of light observed on glass surfaces.

DRAWING GLASS

Light tends to behave capriciously on most glass since it creates shine in different areas. This effect can be rendered by darkening small adjacent parts as you keep the tone of surfaces *behind* the visible objects visible.

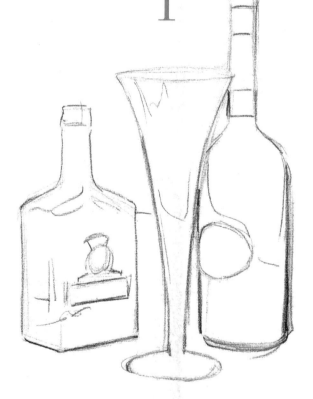

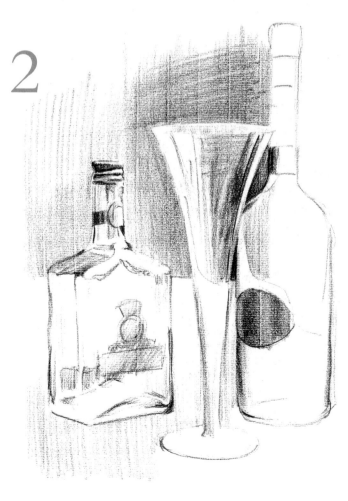

1. Drawing respects outlines and details, but does not insist too much on line—in order to avoid making it too rigid and difficult to work with afterward.

2. The wineglass is shaded with greater intensity on an inner side. The strokes should follow the natural shape of the glass to allow for white spaces that express the shine on the surface.

3. The dark tones of the background are distorted through the different containers according to their shapes. The small areas through which the tabletop is visible should be left almost completely white.

4. In the lower part of the containers we have included a bit of shine, which does not completely disrupt the clarity produced by the transparency that makes the table visible. With this, the drawing is now complete.

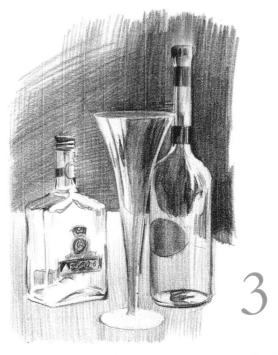

For many artists, still lifes composed of glass objects are an opportunity to show their mastery of technique in what is considered to be a difficult subject. The complexity of the result varies, however, depending on the technique of each artist and the aesthetic interests pursued in the work.

Process of Drawing Glass

The initial drawing should present well-established outlines so that the shapes of the containers will not be confused with the accumulation of contours created by an abundance of shine and reflections. The first shadows should attempt to emphasize some shine in the glass in order to orient the rest of the process. Use progressive layers of hatching wherever the drawing requires contrast to accent luminosity in a shine. It is important that all strokes follow the same, vertical direction in the hatching so that the surface of the glass appears hard and polished. Meanwhile, the tone of the background should be dark enough for the shine of the containers to stand out against it.

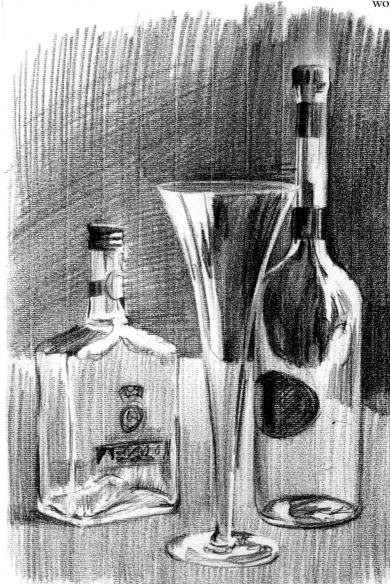

REPRESENTING SHINE
AND REFLECTION ON METALS

Metallic objects frequently pose a challenge in the still life. The polished surfaces of metal create sparkles and reflections that must be drawn carefully if they are not to become a confusing lump of light and shadow. As in the case of shine on glass surfaces, metallic shine is a product of a tight series of very light and very dark areas. The general shape of the object and the direction of the strokes will express the play of light and shadow on the object's surface. It is advisable to include in an initial drawing outlines that mark light and dark areas which are created by the play of light on the metallic surface.

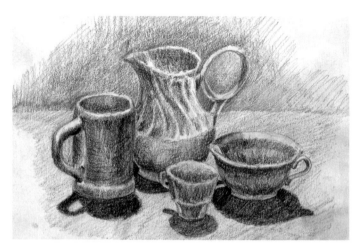

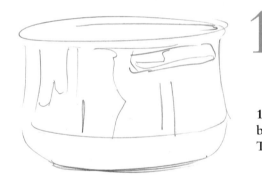

1. Shine on metal can be indicated in the contour drawing by pencil marks outlining stretches of light and shadow. These areas are what make a surface look polished.

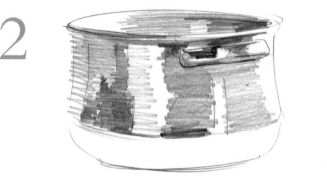

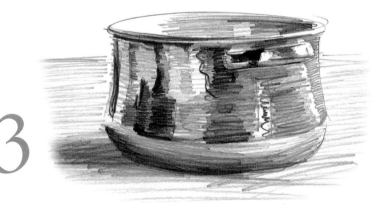

2. The marks in the drawing now serve to distribute the alternating light and shadow that determine the shine. The strokes describe the shape as if it were a matter of representing a cylinder—which, in fact, is what this pot is.

3. The lighter band on the lower part of the container corresponds to the reflection of the table, and contrasts with the coarse distribution of light and shadow in the upper part, which is how light shines on metal.

Form and Tonality of Reflections

Reproducing the exact contour of every reflection on a metal surface would be an arduous task—and unnecessary, because it suffices to identify just a few of them and develop the rest as you go along. Reflections change with point of view—even a slight movement from left to right will alter them completely. This is yet another reason why it is better to pursue a freer drawing, with less attention to exact description, once you understand the logic that governs reflections.

1. Another view of the same pot adds a shine that appears on its interior. Just as before, pencil markings signal the most important boundaries between light and shadow.

2. Again, the curvilinear strokes follow the cylindrical shape of the pot. The strokes overlap or are interrupted depending on the appearance and disappearance of shine and shadows.

3. The last step consists of reinforcing the darker shadings so that white areas left to appear as shine benefit from high contrast.

Pens, markers, graphite or colored pencils, and even ballpoints are well suited for the representation of metallic surfaces. Shading by layering strokes allows better control of the shape, dimension, and tonal intensity of the shadows. The subject we have chosen to develop in this exercise is fairly complex. Each of the metallic objects takes in light differently. Working with lines will allow us to master all the luminous aspects of the subject.

1

1. Before going to work with the markers, make a simple drawing indicating the position of the subject's most significant reflections.

DRAWING METAL

Drawing Reflections

This exercise requires markers of two different tones, bluish gray and black. The two tones allow you to create different qualities of shadow without saturating your strokes. The initial drawing establishes the general lines of the shapes without going into details, marking only some of the important reflections. The more luminous shine is left in white, while the dark areas are covered alternately with gray or black parallel strokes.

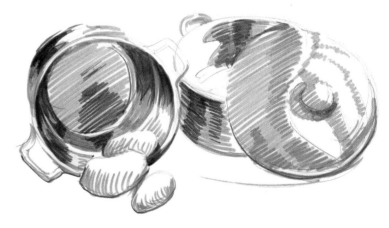

2

2. Heeding the guidelines you marked off in the initial drawing, layer a series of parallel strokes along the length and width of the surfaces, creating areas of different intensity with tight, single-color strokes. For the darkest tones, add nuance with black strokes.

Simplicity is Important

The complexity of polished surfaces, the continuous alternation between light and shadow, may seem to call for a wealth of supplementary details. It is important to remember that lines and strokes themselves add a graphic richness to the drawing, and not to overload your drawing with details. The general drawing should be simple, avoiding an excess of nuance, which distorts the integrity of the form.

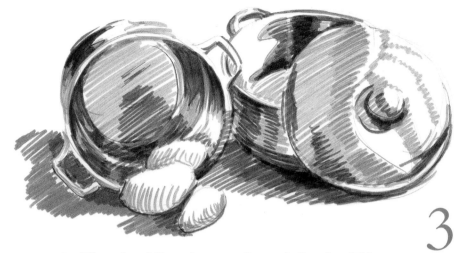

3. All strokes follow the same diagonal direction. This maintains unity in a drawing that, by the complex nature of the metal surface, could end up looking clumsy with an overload of intense light and deep shadows.

4. The final step is to add nuance to the areas surrounding the subject. A series of thick strokes form projected shadows that add a tonal value to the table on which the metal pots are sitting.

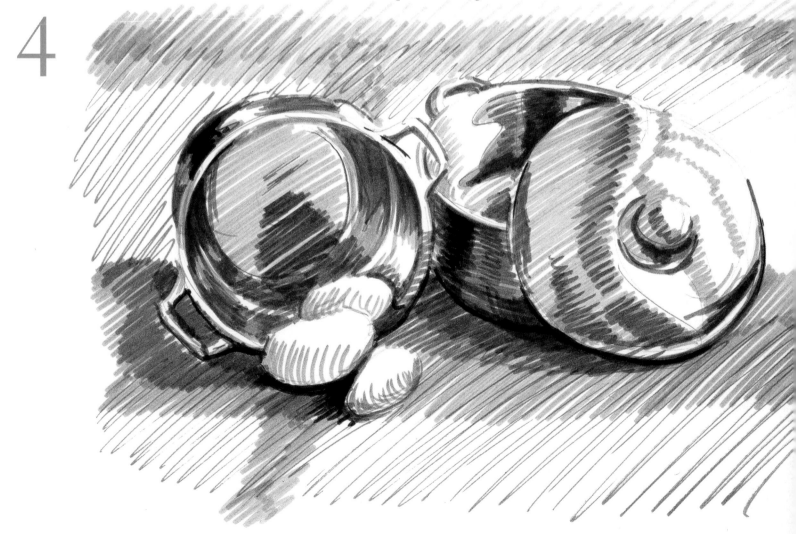

Surfaces,

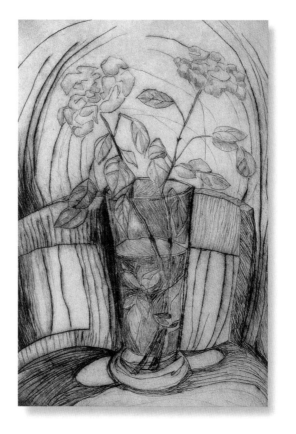

ESTHER OLIVÉ. *ROSES*, 2002. ETCHING.

Textures, AND *Themes* IN THE STILL LIFE

Metal, glass, cloth, fruit, wood—all of these materials commonly appear in still life drawing. Each one has an individual consistency that is evoked, imitated, or suggested in different ways. The style of drawing can accomplish this by being flowing or geometric, continuous or discontinuous, profusely shaded, crosshatched, or highlighted with stains. These characteristics can awaken in the viewer the idea of a particular material, hard or soft, smooth or rough. The drawing itself can evoke all the simplicity or richness of the actual appearance of the material.

DRAPING *in the*
STILL LIFE

The play of folds and wrinkles in fabrics that appears in many still life drawings, such as in tablecloths, curtains, or rugs, is called *draping*. Drapes in drawing are considered abstract configurations of lines, lights, and shadows, and as such possess great compositional and ornamental value. The relief, crests, peaks, and volumes created by the folds in different types of fabric are motifs of great interest to the artist and call for a treatment equal to that given to other objects in the drawing. Drapes also present excellent opportunities for practicing shading.

Draping is commonly used to emphasize a particular area or a significant group of objects in the still life. This is a preparatory sketch for a simple composition with drapes.

The Rhythm of Line

A draping has a rhythmic value when it is arranged in elaborate folds, a pattern called an *arabesque*. Indeed, this style may be the treatment best suited to fabrics, since the arabesque very naturally suggests folds and shadows. The rhythm of the strokes, while rendering an arabesque draping, creates an appealing line configuration. A treatment in chiaroscuro, on the other hand, neutralizes the possibility of arabesque lines, introducing its characteristic solidity and stability.

This simple drawing shows how the contrast inherent in the play of folds highlights the simple, smooth shapes the fabric holds. The hard surface of the fruits is given its tonal value as a result.

Drawing Drapes

The best way to practice the representation of folds is to draw a drape pinned onto a wall in one or more spots (the more places the drape is pinned, the greater the complexity of its folds). Or you can place a rigid or heavily starched rag on a tabletop. The drape should be lighted from the side to show the relief of all its wrinkles and folds and the play of light and shadow on them. The kind of folds will depend on the fabric: thick fabric folds less than thin fabrics, but its folds are deeper and more voluminous.

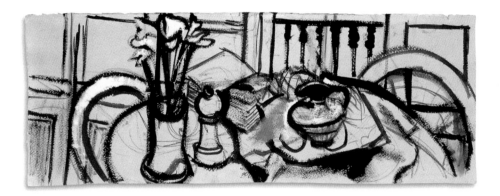

Draping always adds to the appeal and contrast when representing a group of objects. Here a tablecloth introduces a free, ornamental factor into the drawing.

The folds in the draping in the finished drawing clearly contrast broken lines with the rounded forms of the other objects.

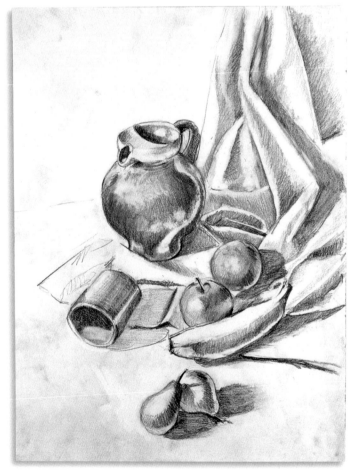

In this image we witness an intermediate stage in the creation of a composition with draping. Rendering the arabesque pattern of fabric follows the same process as other objects in a still life.

DRAWING

DRAPING

The most important thing to remember when using a draping as a drawing model is to place it correctly with respect to the light. The shadows should be significant, accentuating volumes and the shape of the folds, and the shadows should also be varied—of different shapes, sizes, and tones. Choose a sidelong light source that is not too high: the lower the angle of the light, the darker the tonal values of the shadows. You can opt to draw only the draping, or organize an entire still life around your draping, as in the example on the opposite page. Keep in mind that other objects in the drawing can create wrinkles and folds in your draping and that the draping can hide or highlight those objects.

1. It is not advisable to begin the drawing of a draping with a detailed line drawing of its folds and wrinkles. Instead, draw some guidelines for the later stages of shading.

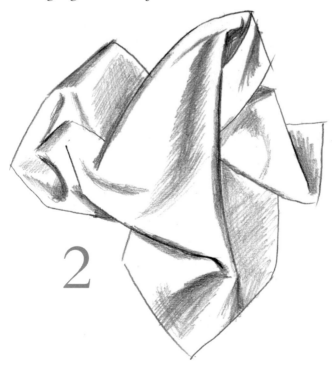

2. The guidelines of the initial drawing mark the folds. Begin the shading within these lines, and shadow opposite the area of the fold to highlight the central relief of the fold.

3. By stressing and grading the shadows, a convincing representation of the ensemble of bulges and indentations created by the draping's folds is achieved.

Drawing and Shading Folds

Work should begin with drawing your basic arrangement with very simple lines, to the point that these lines are reduced to signify the limits between lighted and shaded areas. The shading, here made in pencil, begins with an elementary hatching and continues with successive layers of hatching in the areas where the shadows are deepest. It is essential that the impression of relief and volume be well established.

Volume Imbalance

One of the problems of drawing draping is that sometimes the play of light and shadow is not in balance, and as a result the folds in the draping are confusing to the viewer. The solution is to pay close attention to the disposition of the folds and wrinkles, and start from the lightest shadows and move progressively toward the darkest.

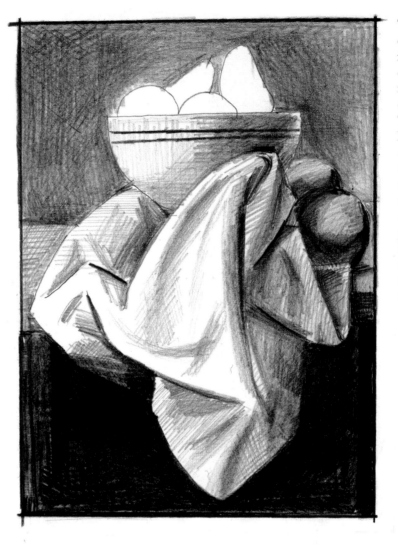

This finished drawing incorporates the draping represented in the earlier exercise. The variations in light and shadow are due to the arrangement of tonal values in a wider ensemble of objects. The purpose of the still life is always to highlight the thematic elements of the work.

Draping must always be drawn in the spirit and style of the work. A close attention to detail is often unnecessary. The important thing is for the draping to serve as a frame, and that it contrasts with the other elements of the drawing.

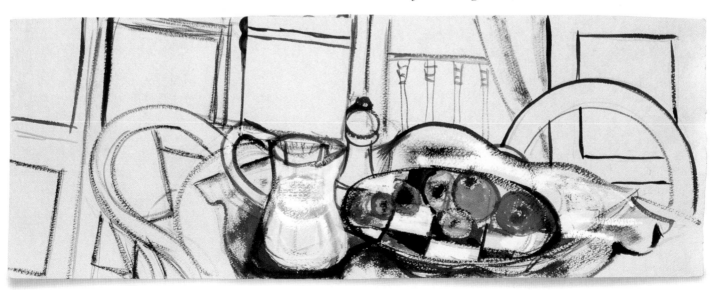

DRAWING
FLOWERS

Flowers are among the most attractive themes in still life drawing. Their highly varied formal characteristics can be adapted to any artistic style or aspiration. Flowers can be drawn using the standard process of the geometric sketch, outlining of contours, and shading. But the exceptional consistency of a flower's petals and leaves suggests freer, more spontaneous forms in the hands of an experienced artist. The following pages show a common drawing process applied to the representation of flowers, as well as other, freer possibilities.

Backlighted flowers usually call for an emphasis on the stroke and line. Here it is barely possible to distinguish between true lines and spots of shadow.

In this drawing the shadows have been reduced to a minimum. By not exaggerating the dark tones the linear rhythm of the petals and leaves of the bouquet is realized.

Flowers and the Geometric Sketch

In most cases, the light, delicate tones of flowers encourage minimal inner shading, avoiding an overemphasis on the shadows that give shape to the petals. To accomplish this without forsaking volume, we darken the flowers' outlines so that their shape and relief are highlighted by contrast. In the geometric sketch, this may be a matter of darkening the basic lines so that the flowers stand out in relief.

Flowers can be little more than a doodle, or a group of doodles, in the drawing. The floral form is so mobile and indeterminate that a more or less orderly grouping of markings made with imagination and good taste is totally acceptable.

1. This initial drawing of a group of flowers follows the process you've learned of sketching simple forms with geometric tendencies. These forms determine the general outline and size of each flower.

2. Contours round out the geometric sketch, and here the contours closely approximate those of the flowers. Inner lines serve to order the distribution of the petals.

3. The white areas in the interior of the petals add to their lightness; strong shading would contradict the suggestion of lightness. To achieve relief and volume in the petals work in negative, darkening the outlying rather than the interior shadows.

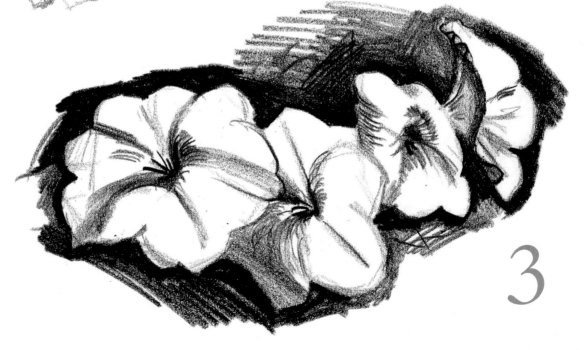

MODE *and* STYLE *in*
THE DRAWING OF FLOWERS

Flowers are the ideal theme for practicing distinct and original graphic approaches. The appeal and formal richness of their contours and details suggest many different approaches, from a sparse line drawing to the freest washes of watercolor or ink solution— which are just a step removed from painting. Freedom and creativity are the key factors in all of these variations.

The simplicity of a flowing line is extremely useful when sketching a floral theme.

This sketch is a combination of line and stain. The details of the petals depend on fine lines made in ink, which contrast sharply with the energetic colored ink stains that express the leaves.

Freedom of the Stroke
When drawing flowers, too much precision in the stroke can lead to stiffness and coldness in the final result. All parts of a flower are flexible and tender, and this flexibility and delicacy is best suggested by an equally flexible and delicate stroke. Experience in conventional drawing is the starting point for interpreting flower still lifes daringly, making strokes that do not rely on a predetermined program and instead develop from unfettered, agile inspiration.

The combination of lines and spots of color is most effective when the two techniques are employed only in certain parts of the drawing. Here the spots of colored ink define the flower's texture while the fine ink lines take care of the rest.

Greater or lesser control over stains results in either a silkier or a more descriptive finish. The type of flower will suggest one approach or the other.

Freedom in the Stain

Line-based drawings find a graphic complement in the use of stains. Watered-down ink applied with a paintbrush combines well with conventional line drawing techniques. The line itself can be made in ink, charcoal pencil, or watercolor pencils. The possibilities are many, and the most interesting still lifes of flowers are based on a spontaneous use of the materials and on not placing too much importance on the strict limits of the drawing. Spots of color often yield better results when they do not perfectly circumscribe shadows and instead create general contrasts.

In this delicate drawing the intensity of the stains, which were made using a diluted ink solution, results in an expressive representation of the effects of light upon the many different surfaces of the rose and vase.

USING DRY STAINS *to*
DRAW A FLORAL THEME

Stains are not limited to ink and watercolor; as long as the materials are used decisively and energetically, stains can be made using dry media such as charcoal. These pages show the process of drawing a vase full of tulips using a charcoal stick and working "in negative"—drawing around the shape so that the form of the flowers is expressed by contrast against a very dark background.

1. The drawing begins with a quick sketch of the contour lines of the tulips in the vase. The theme will be a "positive" block against the "negative" of the background. The contour lines roughly mark the border between these two elements.

2. The energetic background lines in charcoal are not exactly a shading but a distribution of contrasting stains with a single purpose: to assign a tonal value to the flowers. The contour lines are not scrupulously respected, and instead are used as guidelines for the staining process.

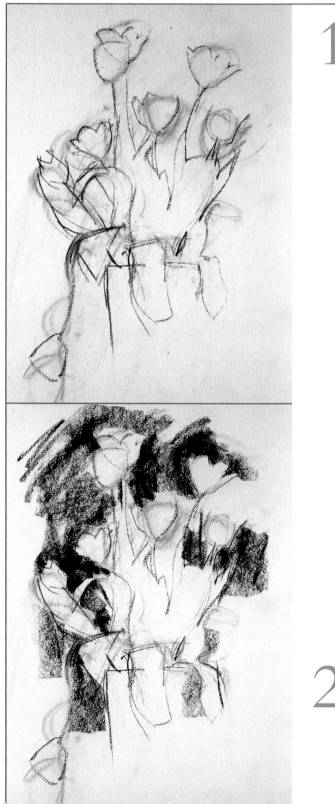

1

2

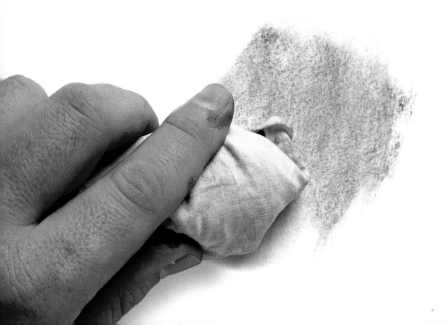

Process of Staining

A drawing based on stains requires an open initial sketch without strictly defined limits of the theme's shapes. This is important because the effectiveness of the stains depends on their visual force, which is only accomplished with spontaneous staining. It is not necessary to be concerned about whether the stain invades the interior of another form, because stains and forms can be accommodated together. Using a stumping cloth to fade and blend allows you to better determine the shape of the stains and create different tonal values in the flowers and leaves.

Charcoal stain is faster and more powerful than water-based stains, which are very delicate, as the illustration shows.

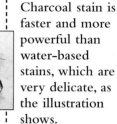

3

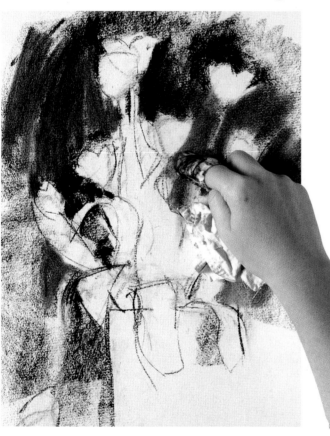

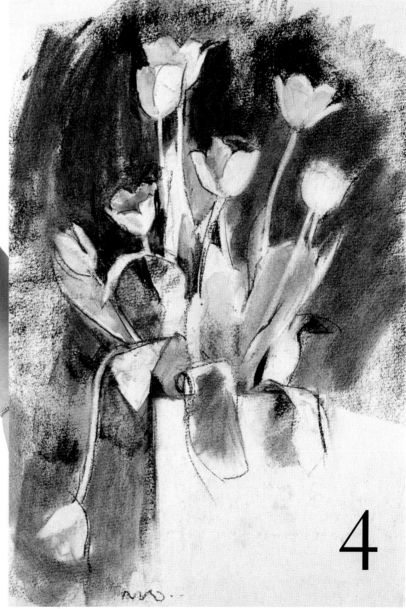

4

3. The stains are faded and spread using a cotton cloth. This stumping technique provides a clearer definition of the silhouettes of the tulips. It isn't necessary to orient the stains in the background because their only function is to emphasize the theme of the flowers.

4. With a cloth saturated with charcoal powder add some inner shading to the flowers—leaves, petals—but only enough to break with the whites in the block of flowers and articulate its shape. With this final stumping the drawing is finished.

The choice of objects and themes that can be represented in a still life is endless. Outside of a human figure or a landscape, anything is possible as a subject. Here are a few suggestions that might stimulate your interest and curiosity and guide you toward discovering subjects you may have otherwise overlooked.

OTHER
SUBJECTS AND
SURFACES

This drawing shows a fruit stand and its various and sundry items ingeniously displayed to the public. The artist's subject is already perfectly arranged here, ready to be drawn or photographed for later use.

Though this apple tart may seem an unusual choice, subjects such as this boast a long tradition within the still life genre. Today's bakeries and markets are a place where the artist can renew and update this tradition.

Large pieces of meat are also recurring themes in the classical still life. The intricate texture and surfaces offer a complex and fascinating subject for the adventurous artist.

Food Themes

Fruits, as captured during a leisurely stroll through a market rather than arranged in a bowl, can be a revelation. The arrangement of meats, fish, and vegetables in a grocery store is also an inexhaustible source of inspiration. In many cases the artist doesn't need to think about the theme or its composition because it is already perfectly arranged and presented. In addition, the great number of surfaces and material qualities of different fresh foods is a source of interest for any artist.

Clothes and Everyday Objects

The things we see every day often go unnoticed, which is a good reason why we should pay attention to the objects around us. Our clothing (shoes, especially), objects we use frequently (a suitcase, an umbrella, eyeglasses), toys, home decorations—all have the potential to become excellent subjects for a drawing. Just look around and you will discover unlikely subjects that are rife with possibilities for a still life.

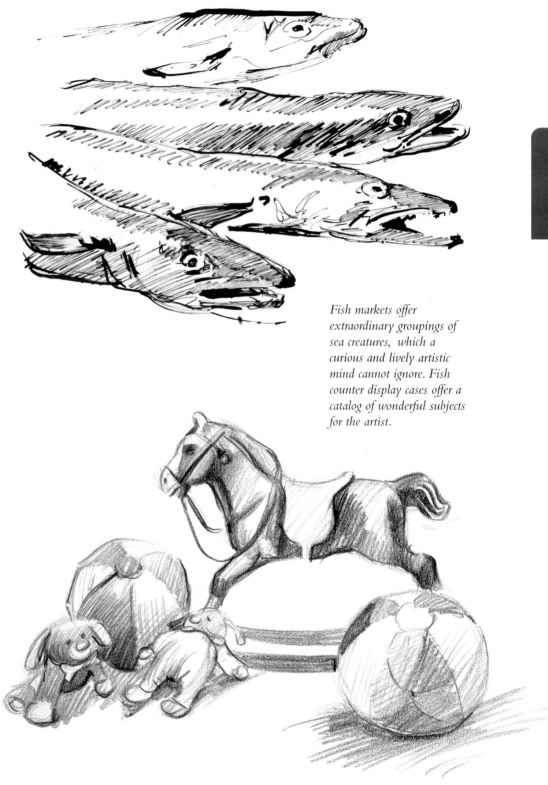

Fish markets offer extraordinary groupings of sea creatures, which a curious and lively artistic mind cannot ignore. Fish counter display cases offer a catalog of wonderful subjects for the artist.

The most ordinary objects, items we tend to ignore from day to day, are potential subjects for still life. The intimate values they possess surpass their formal appeal and suggest compositions animated by affection and warmth.

THE COMPOSITION OF A

"What we call creation in the great artists is nothing more than their particular way of seeing, coordinating, and reproducing nature."

Eugène Delacroix (1798–1863)

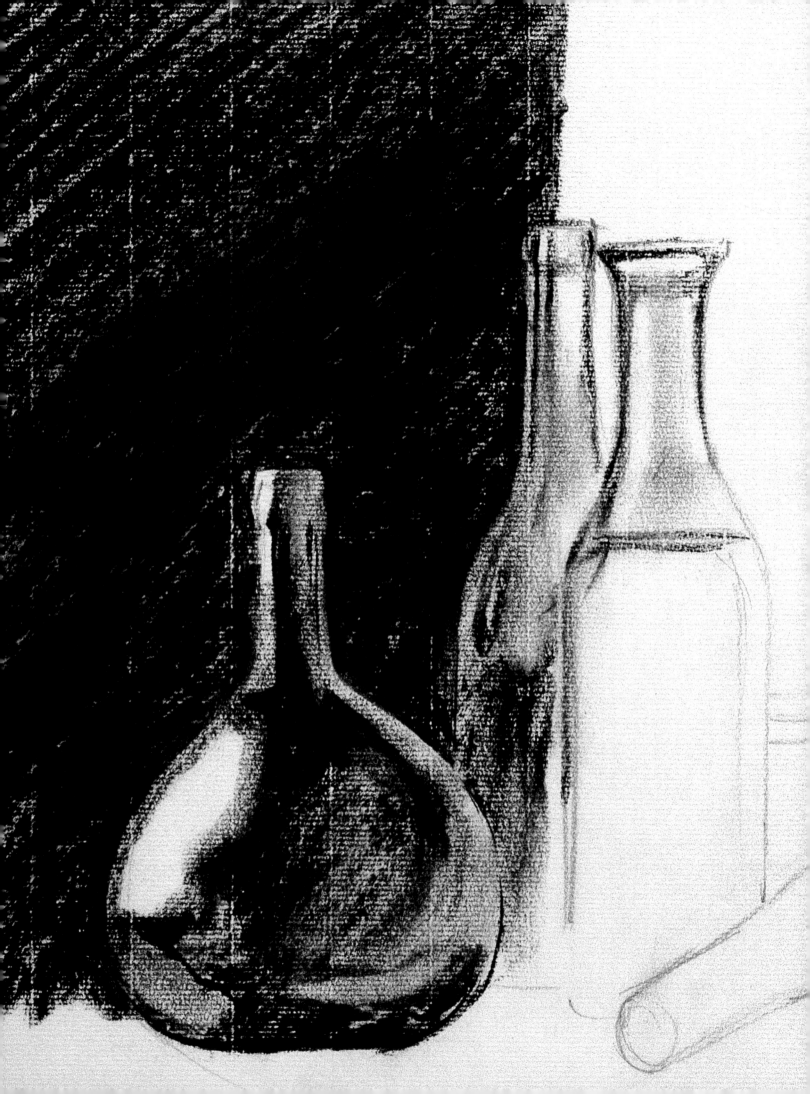

Organization

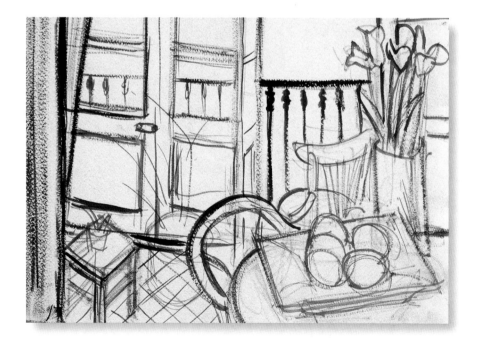

DAVID SANMIGUEL. *STILL LIFE IN AN INTERIOR*, 2003. CHARCOAL.

AND *Balance* IN THE STILL LIFE

The balanced arrangement of the elements that results in an organized, unified and harmonious whole in a drawing is its composition. A well-composed drawing can be compared to a perfectly designed building in which all of its elements (windows, columns, cornices, and so forth) are integrated into the whole so that it attracts our attention and piques our interest. Line, shape, texture, stain, and chiaroscuro are those elements, and organizing them is the goal of the compositional process. Composition is a matter of calculation but it is also one of intuition. Sometimes something "works," but we don't know exactly what it is—that something is usually the composition. The following pages show how to discover it.

BASIC COMPOSITION
PRINCIPLES IN STILL LIFE DRAWING

Although there are no foolproof recipes for achieving well-balanced compositions, the principles of unity (symmetry) and variety (asymmetry) are essential guides to drawing still lifes with success. This is especially true of drawings in conventional formats, that is, standard sizes that are neither very tall nor very wide. The organization of the drawing should adjust to the space without becoming too static or too dispersed.

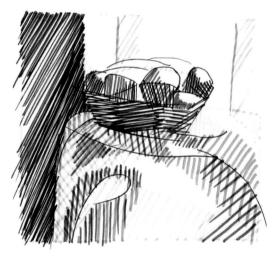

A simple composition, centered, guarantees a unified quality. However, it runs the risk of being too symmetrical, which can make the drawing appear static or inert. This drawing avoids that pitfall by shifting the subject, the basket of fruit, from the center toward the upper half of the drawing. Furthermore, the black bar along the left side breaks the symmetry between the left and right sides of the drawing and harmonizes the composition.

Symmetry and Asymmetry

The principle of symmetry is an elementary factor in composition. Symmetry means the balance between lines and shapes that provides unity. A good composition develops somewhere between the two poles of symmetry and asymmetry: total symmetry and total asymmetry are extremes to be avoided. Symmetry, in its perfectly stable order, can imply immobility. So even though symmetry is the surest, most direct way to achieve a unified effect, it may, if misused, come at the cost of visual appeal.

Freedom and Regularity

Asymmetry offers a greater degree of compositional freedom than symmetry. It allows for a freer, more intuitive arrangement of objects where balance is achieved through other, more varied processes. Asymmetry reflects our normal way of viewing the world, and it therefore implies naturalism and realism. Asymmetrical works are generally characterized by their variety, motion, and spontaneity of vision. But excessive asymmetry can create an imbalance, dispersing the composition and destroying its visual appeal. Objects should not be too far from one another, for example—if they are, they not only call attention to themselves individually, but the viewer's attention will be exhausted by moving from one object to another without finding "regularities," or transitions.

The unified whole of the composition is varied and harmonious: the objects relate to one another with regularity. This means, as in this drawing, alternating masses and volumes, combining empty spaces and clusters of objects, so that all is proportionally balanced. If a composition is too tight or too scattered it will never be balanced.

A small subject can exert a powerful pull on the viewer's attention if it is situated at the right point in the composition. Here the basket of fruit is at the vertex of a compositional pyramid with lines leading upward toward the left side of the drawing. The combination of asymmetry and linear direction makes a minimal subject a compelling visual.

Here the basket has been shifted to the right. To compensate for the greater visual demands in this area, a dark vertical band has been added on the side opposite the compositional focal point, the basket.

COMPOSITIONAL
SCHEMAS

A linear platform in a composition is not enough to organize the picture clearly and firmly. Some of the directions of the lines must be emphasized to the detriment of others so that the composition achieves a stable unity.

Whether the subject is complex or elementary, every picture is born of a simple compositional schema, or plan, in which the different aspects of the subject are organized. Every experienced artist will develop schemas that include certain subjects and certain ways of composing and organizing light and shadow upon the page. The simplest schemas are generally the best, for they preserve the freedom of the artist while adapting to almost any subject.

Orthogonal Composition
This type of composition organizes the drawing based on a right angle, which creates an assured balance. Since it can be adapted to almost any subject, it is an appropriate schema for composing still lifes with many different elements. Compositions in L and U shapes are right-angle variations of orthogonal composition. In an L-based schema, as here, a horizontal distribution along the base of the drawing has a vertical element that closes the composition on one or both sides. The quadrangular space that is left can be interpreted as a space in depth, and can be resolved as an area that serves to balance the primary subject.

The system of lines that forms the basic schema of this composition has been summarized in an orthogonal L-shaped configuration that unites and simplifies the motif, creating a coherent compositional space.

Diagonal Composition

Depth and dynamics can be achieved through composition alone. The simplest and most effective means of doing so is diagonal composition. Diagonals crossing a canvas suggest depth and space. Still life artists use diagonal composition to assume a point of view. The trajectory of the diagonals direct the viewer's gaze toward the far end of the drawing.

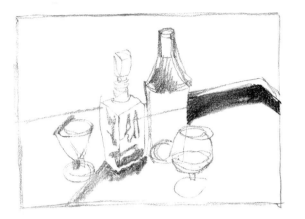

The edges of the table describe the trajectory of the diagonals. The dynamics of this compositional schema lend spatiality and depth.

Diagonals create a sense of dynamics in any composition. In general, they direct the viewer's gaze either toward the distance in a drawing or draw it closer to the foreground, which means that they help to express spatial depth.

This initial sketch shows exactly the same subject as the one on the opposite page, but the different point of view imposes a modification on the basic compositional schema and highlights the motif as the focal point.

Here a U-shaped compositional schema subordinates the lower part of the composition in order to highlight what is really of interest—the objects on the table.

FRIEZE

COMPOSITION

A frieze in still life is a series of objects arranged horizontally along the length of the drawing, rather than in its depths. A good fit for still life drawing, this configuration presents the elements of the picture with maximum clarity, though it tends to be rather static, which invites the artist to think of different techniques to make the composition dynamic. Frieze composition is best suited to a panoramic, horizontal format and to subjects that maintain regularity in their size and shape, so that together they create a uniform band.

Foreground and Depth in a Frieze

Frieze compositions—that is, compositions in which the objects are lined up next to one another, tend to lack depth of field. Since objects run along the horizontal lines of the canvas in a frieze, there is no room to create an illusion of depth. But the artist can make use of diagonal strokes, or move some objects forward while pushing others farther back, to break with the line of a static foreground. Another technique is to model some parts of the drawing energetically, leaving others virtually unshaded.

This is a typical example of frieze composition. The objects are positioned next to one another, as in a family portrait. The challenge is to combine their sizes and shapes in such a way that the composition is not a procession of objects but an interesting and compelling grouping. One technique is to push some of the objects backward or forward, as you do when posing people in a group photograph.

Suitable Subjects for Friezes

Travel souvenirs, postcards, toys, pottery, food containers, and other such objects tend to be placed next to each other in cupboards or on shelves. Many artists arrange objects in a frieze composition just for the pleasure of drawing them because they have sentimental value.

1. To avoid an excess of flat surfaces in a very wide, or panoramic composition, the diagonals in the general sketch must be decisive. Here the diagonals are determined by the perspective of the cupboard: the plane runs diagonally rather than horizontally, which should have no effect on the legibility of the objects that are lined up here.

2. The distribution of these objects, although strictly horizontal, is not monotonous or troubled by an excess of flat surfaces. The diagonal orientation encourages visual dynamics, which is underscored by the variety of shapes in the motif.

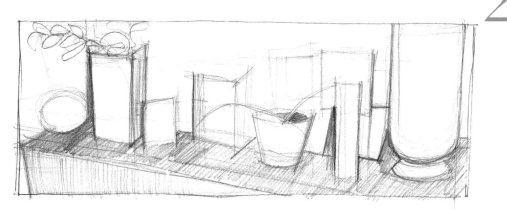

3. The finished drawing shows how a diagonal composition lends relief and depth to a frieze, despite the linear arrangement of the objects within it.

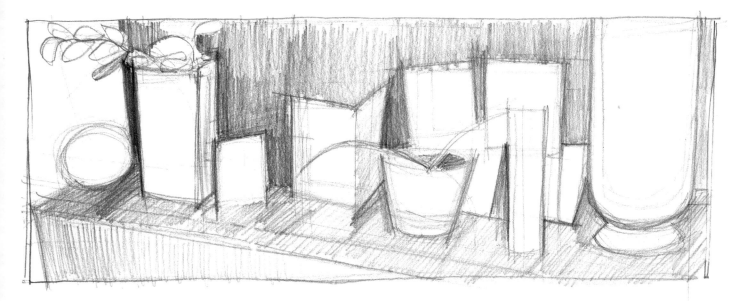

OTHER STYLES *of* COMPOSITION

Ideally, every motif should suggest its own unique composition to the artist, but the fact is that artists accommodate their motifs to compositions they know well and in which they are certain to achieve a harmony and stability. This chapter couldn't ignore other compositions that, while less commonly used, are appealing in their own right. By exploring possibilities that present interesting artistic options the artist's originality becomes evident.

Vertical Compositions

Vertical compositions in painting suggest serenity and calm, and a vertical still life also assumes these qualities. While groupings of objects usually are presented in horizontal arrangements, it is by no means rare for a still life subject to demand a vertical composition. As seen on this page, you can always use an interior architectural setting as an excuse for practicing the vertical variation.

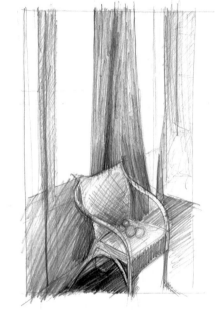

Still lifes of an interior setting lend themselves to vertical composition. Architectural surroundings offer a myriad of opportunities: doors, windows, curtains, columns, and even simple stretches of wall are substantial motifs in which vertical lines play the lead role. The effect is always one of spatial calm.

The Cubist painters, especially Juan Gris, made deep explorations into the use of vertical schema to confer solemnity and dignity on the humble still life genre. In this reconstruction of a Gris painting, nearly all the defining lines are perfect verticals, which give the composition a tranquil appearance.

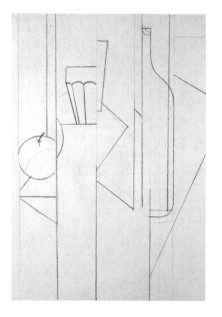

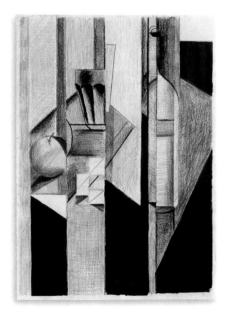

Oval Compositions

The oval format evokes Romantic painting, especially portraiture, but examples abound of still lifes in this format. It isn't an easy composition style to use, because the objects must be adjusted to an unusual space that calls more for curves than angles. For this reason, it is a good idea to choose curvilinear objects, or objects that can be drawn using oval shapes that will harmonize with the compositional whole.

The oval composition possesses a great charm, but it demands a harmonious choice of motif. In general, the simpler the theme, the greater the chance the artist has of achieving a successful result. Here, the curved contours of the bottle are in harmony with the oval format.

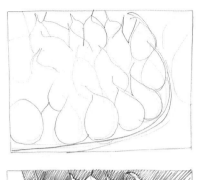

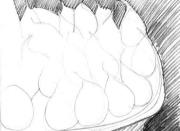

In this unusual representation of a basket of fruit, the viewer interprets the composition as an oval or near-oval. Although the format is conventionally rectangular, the principal line in the drawing curves to envelop and give unity to the subject, as in an oval composition.

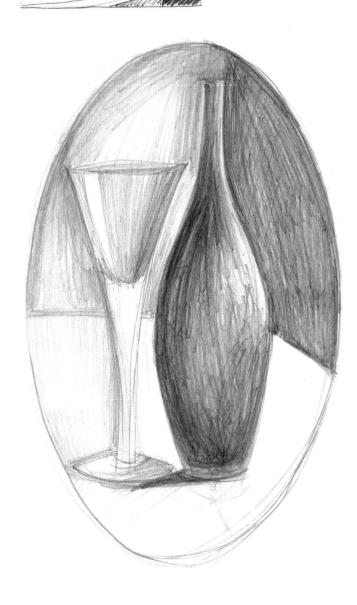

The DEVELOPMENT *of a* COMPOSITION

<div style="text-align: right;">1</div>

Sometimes a chosen motif provides an opportunity to carry out all the applied operations in a composition with a high degree of accuracy. Such is the case with the example on these pages. It is a subject made up of toys and children's building blocks similar to those you drew in the sections on geometric shapes. The subject is composed of regular shapes that invite compositional speculation.

These two sketches show the composition in this drawing. The L shape composition, with two diagonal lines crossing, frame the scene.

1. This tangle of lines in the initial sketch reveals the compositional guidelines. Just as the little sketches to the left show, the initial sketch is governed by two diagonals and a right angle (the L shape) in the center-right area of the drawing.

<div style="text-align: right;">2</div>

Compositional Guidelines
Interestingly, the shape and position of the objects are almost immediately realized by drawing basic compositional lines on the paper. As these lines connect and interrelate, the objects emerge in more precise form. The only element not determined by the compositional guidelines is the shading, which is limited to bringing out the relief of each object. The drawing is made entirely in pencil.

2. When some contours are emphasized, the compositional guidelines become even more visible. An insistence on the composition lines lends greater precision to the geometric nature of the elements in the drawing.

3

3. When few shadows are added, the shapes acquire depth and volume, and the compositional rigor is not softened or faded.

4. The finished drawing is an example of how to develop a still life composition, rigorously applying the compositional notions of unity, harmony, and stability with success.

This simple drawing suggests a compositional rigor comparable to that of the example shown on these pages. Here, only those lines that are strictly necessary appear. Overworking a schema like this would mean ornamenting the surfaces and inevitably weakening the compositional form.

4

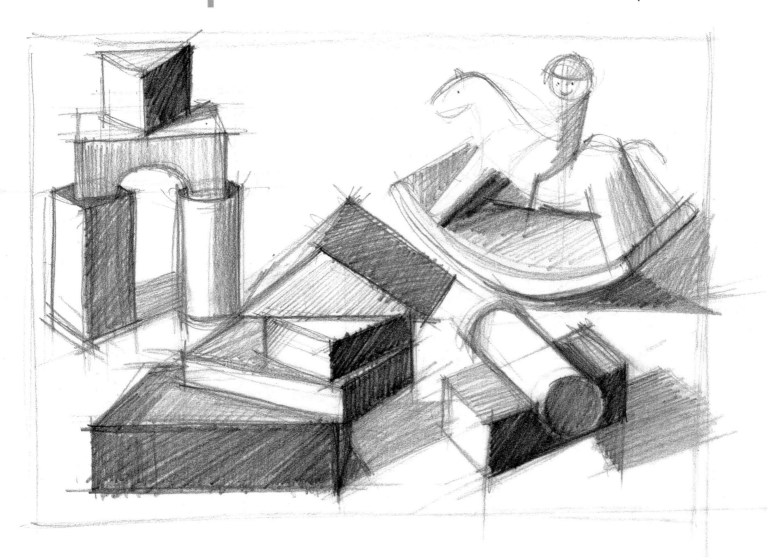

THE
Compositional

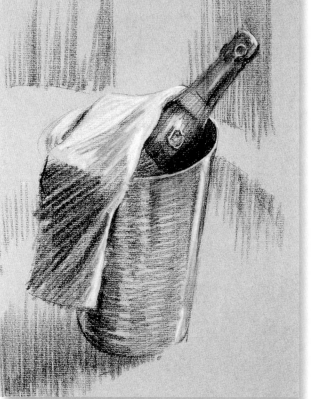

ÓSCAR SANCHÍS. *CHAMPAGNE BOTTLE*, 2004. PRESSED CHARCOAL.

Space: SHAPE AND NEGATIVE SPACE

Composing means organizing, and the composition of a still life begins the moment you place different objects on a table. Later, when you start to represent these objects, you will face the question of shape and depth. Each object or form in the drawing occupies a space that counts a great deal. The latter is known as "positive space." But *negative space*, the empty space in a drawing, is every bit as important to the composition. Negative space is an undeniably substantial, if subtle, part of composition. Only with a full comprehension of this concept can you attain a truly balanced composition, arranging not only the objects but also the "empty" space around them.

Shadows tend to be amorphous, with no clear limits. They present a problem in a composition dominated by clarity and order: uncertain stains appear around objects and forms, spoiling the arrangement.

The FORM and
COMPOSITION OF SHADOWS

One solution, though a drastic one, is to eliminate shadows. Another is to limit shadows and give them a definite shape. Such a drawing will always be an invention, an abstraction, but if we manage to accommodate these shadow forms by making them objects within the still life, we can neutralize the bland, inexpressive effect of uncertain spots of shadow.

1. The drawing is based on just a few precise lines that delineate the space occupied by the folds of the cloth and the objects on top of it. As a compositional factor, the shadows should have this same definition. At the outset of the shading process, all the spots are the same shade and are arranged in locations with well-defined shapes and limits. Somehow the shape of the shadows harmonizes with the geometric style of the initial drawing.

2. Multiply the nuances in the shadow areas, taking care not to lose precision in these dark spots. The variety in tone gives the drawing a sense of volume and relief.

3. The planes of shadow originate in the planes of light, so it is possible to see with total clarity how some of these illuminated planes seem to move forward while others move back. In this way we have represented volume in the composition without having to model the objects themselves.

1

2

3

Shadows as Independent Shapes

Shadows can have a compositional value if they are carefully delineated and their tones graded and valuated in the same manner as the objects in the drawing. For this reason, it is necessary to preserve a structural vision of the work and reduce uncertain or poorly defined areas. This way it is possible to treat the shadows as true visual planes with a concrete spatial presence—a specific position in space—just as the solid objects have a precise location within the drawing.

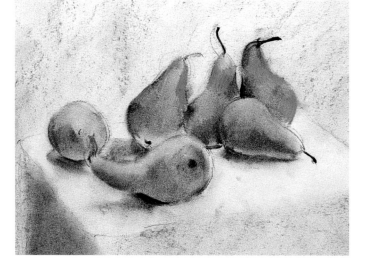

The drawing does not have to assume a geometric character for the shadows to play a structural role. In this still life of pears, the shaded spots appear in concrete, clearly delineated locations that bring an absolute clarity to the representation.

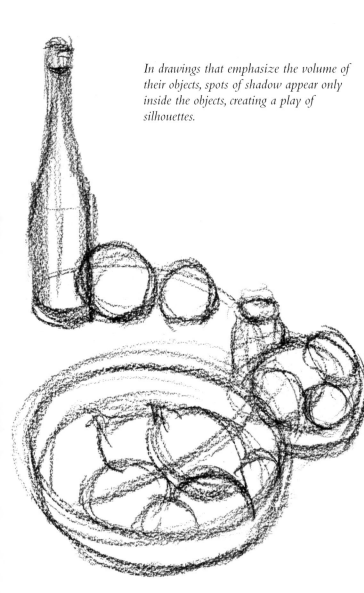

In drawings that emphasize the volume of their objects, spots of shadow appear only inside the objects, creating a play of silhouettes.

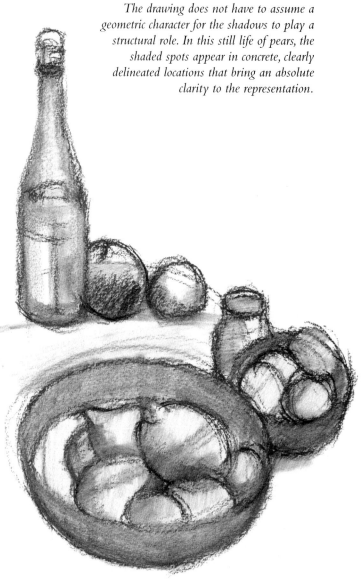

SIMULTANEOUS
CONTRAST

If a light gray tone is bordered by a very dark tone it will look nearly white; conversely, if a spot of shadow is bordered by the white of the paper it will seem darker than if we surround it with black. The greater the number of tones that make up the drawing, the deeper the contrasts will appear. This effect is known as *simultaneous contrast,* or "the law of simultaneous contrast." It allows the artist to intensify or modify tones by means of neighboring tones.

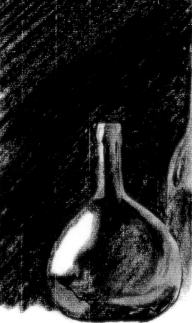

Simultaneous contrast allows tones to define the objects in the drawing rather than obscure them. To keep the object from becoming too enclosed within its own contours, there should be areas within the object that blur into the outer areas.

The complex form of the draping is defined by its own shadows, and also by the adjacent darker shadows that cut into its silhouette and bring out the draping's contours. This effect is called simultaneous contrast.

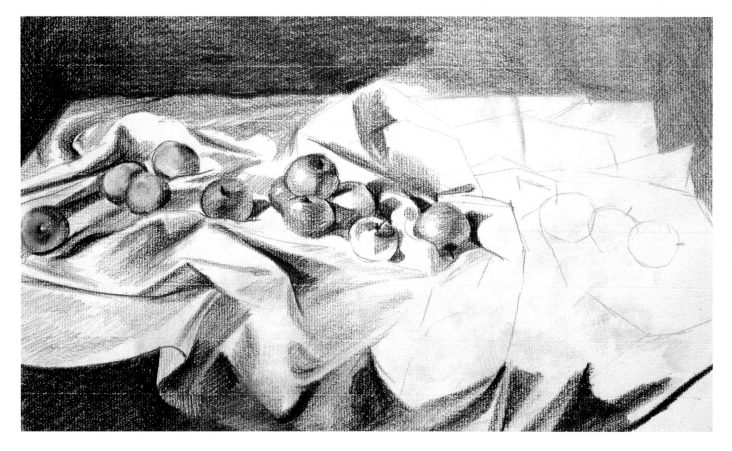

A line drawing defines the contours of geometric shapes to perfection. To keep the shading from destroying this integrity we use simultaneous contrast, and let the light and dark areas "draw one another."

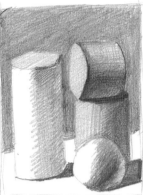

Highlighting Contours

With simultaneous contrast, the artist can accentuate and highlight an object's contours without having to enclose them in a dark line, which often restrains a form and makes it rigid. All that is necessary is to lighten the background tones on the borders of the dark parts of the shape and darken them in the lighter edges and borders. By surrounding the interior of a light-toned fruit with a dark tone we create a contour line without actually having to draw one. The same thing happens when we darken the exterior of a light-toned object. In this way the line and the stain form an inseparable unit—the lines emerge from the shadows.

Transitions

As long as simultaneous contrast isn't used in a mechanical, systematic way it is a valuable technique for defining contours without using lines. If we surround a shape on all sides it is going to look as though it were pasted onto the background—the effect will be choked and artificial. Leave room for the fusion of some parts of the background form—in other words, ensure that the object doesn't blend too much or too little into the background.

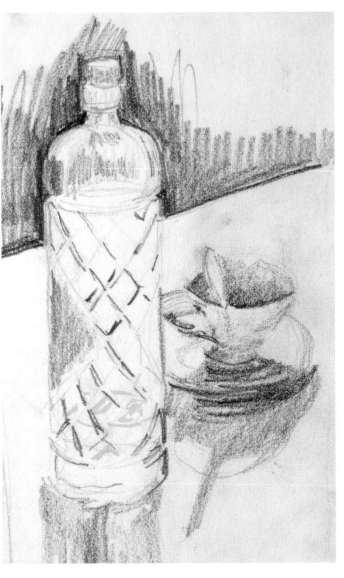

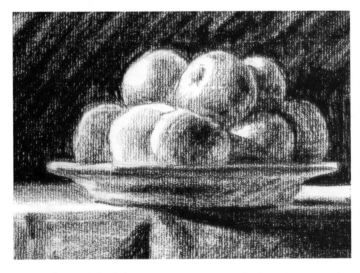

The contours of the lighter areas are accentuated where they meet the darkness of the background. The inner modeling of the apples is an extension of this same principle—some apples bring out the light and shadows of other apples in the bowl.

Even in very sketchy or lightly shaded drawings it is possible to use simultaneous contrast to bring out light-toned objects without darkening their own shadows or inner modeling.

SIMULTANEOUS
CONTRAST AND VOLUME

Simultaneous contrast is especially useful for protecting volumes, which appear with greater force and precision when free of unnecessary lines or strokes from the shading process. As an example, the drawings on these pages were made based on groupings of plaster "abstract" or sculptural objects that lend themselves to the representation of their volume and little else, because even their color is unremarkable and neutral.

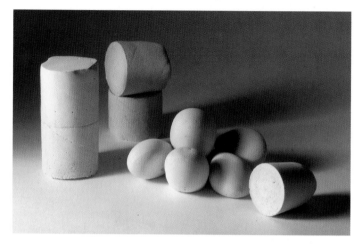

These plaster shapes were molded from balloons and small cardboard tubes. Many other geometric shapes exist for practicing volumetric drawing, but these pieces have an aesthetic appeal of their own, which makes them a good subject for an original and imaginative still life.

Unity and Form of the Background

Forms or objects stand out against a background, but the background, too, plays an important role that must be reflected in the drawing. Using simultaneous contrast, form and background are integrated into a single unit. The background thus becomes a negative space occupied by an object, rather than an independent plane or surface on which objects lie but beyond that does not interact in any meaningful way with the positive space. Many drawings fail because a balance between the objects and the negative space they occupy was not established.

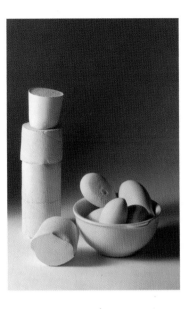

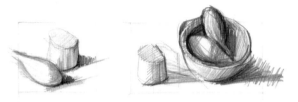

A curious composition made with molded plaster shapes. Shapes like this, rotund and lacking details and color, are good choices for practicing the technique of simultaneous contrast and the play between volume figures and background.

These drawings show the importance of the relationship between negative background space and its tones and the solid forms that occupy the foreground.

These sketches of molded plaster pieces give rise to drawings that could pass for fully realized still lifes.

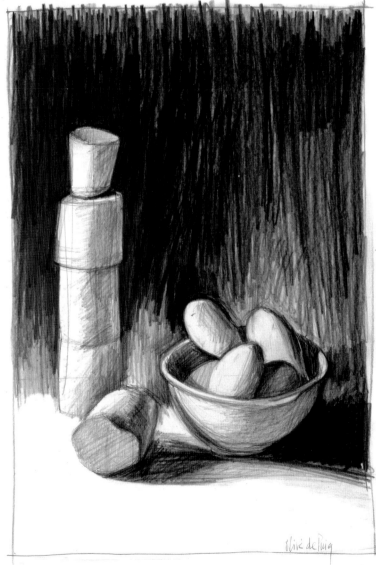

The balance of space in the composition isn't only a question of linear composition. Two other factors are of equal importance to the success of the drawing: the way in which the negative space contributes to the visibility of volume in the objects, and how the objects, through simultaneous contrast, clarify the degree of depth in the background.

OPEN COMPOSITIONS
AND THE FREEDOM OF THE SKETCH

The compositions you have been studying in the preceding pages are *closed compositions*. Theoretically, only these kinds of drawings are considered compositions in their own right. But it would limit still life drawing far too much to leave out *open compositions*, that is, spontaneous works, including the quick sketches that artists make on a daily basis. Indeed, sometimes these sketches are the most interesting creations in the oeuvre of a still life artist. The following pages present a gallery of sketches in different media that testify to drawing borne of freedom and confidence.

These two quick sketches in graphite pencil show grace in their rhythms and an arabesque quality in the line. These qualities are gained by putting aside emphasis on technique and letting intuition be your guide. Naturally, a great deal of experience is necessary to work with the simplicity and looseness that shine in these drawings. Drawings by Mercedes Gaspar.

Although much more elaborate than the usual sketch, this graphic rendering of flowers is nonetheless an open composition. It indicates no reference to a concrete format or size, and unfolds freely on the white of the page. Drawing by Óscar Sanchís.

This sketch demonstrates a great ability for a sharp vision of form: in just a few lines the artist has managed to express perfectly the concavity of the umbrella and its exact position on the tabletop. Drawing by Mercedes Gaspar.

Ink staining is not a particularly agile procedure because it requires precise control over the water and ink solution. Even so, in this ink work the artist manages to transmit freshness and immediacy without distorting the configuration of the roses. Drawing by Mercedes Gaspar.

Markers and ballpoint pens are well suited to making free and spontaneous drawings. The freedom and graphic fantasy in these two drawings are authentic expressions of the artist, inspired by simple bunches of flowers. Drawings by Esther Olivé.

Step

BY

"Style is one's personal method and means of drawing. It is born of the particular talent of each artist in the application and use of his ideas."

Nicolas Poussin (1594–1665)

Step

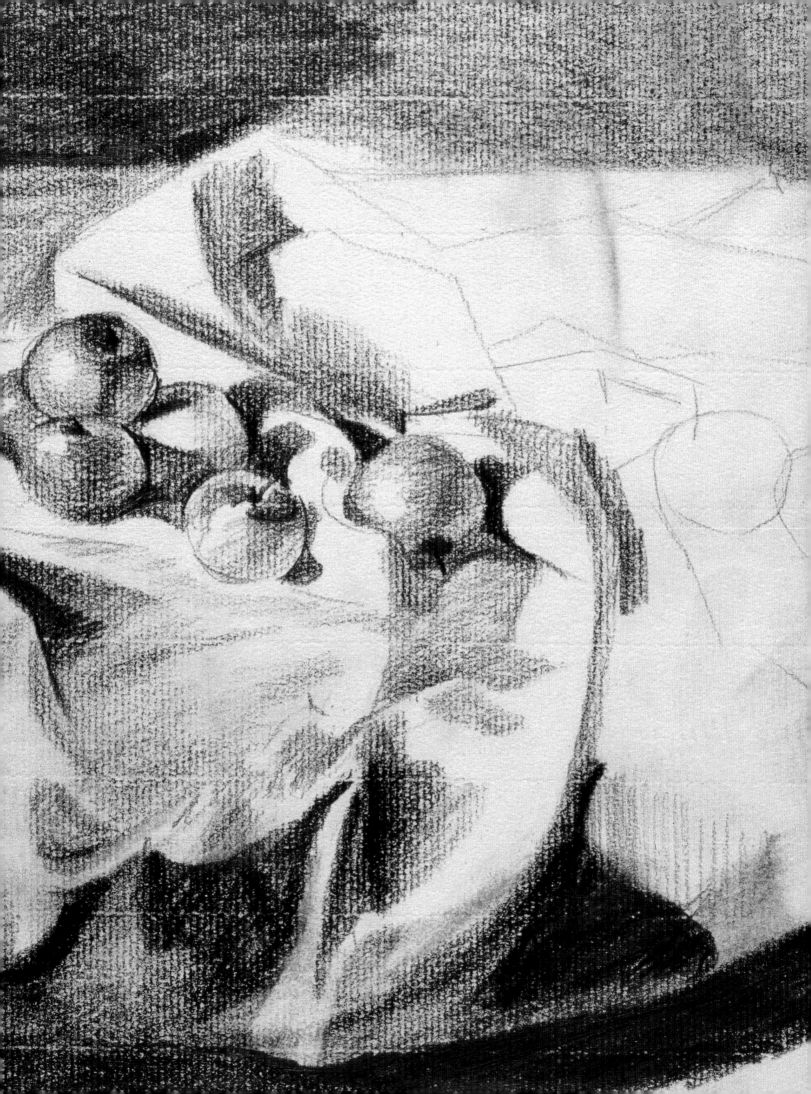

STUDIES *for a*
STILL LIFE WITH ABSTRACT SHAPES

The best way to anticipate substantial problems in the drawing of still lifes is to make studies of shapes in which those problems present themselves. To this end, this exercise is organized around shapes made by rolling, folding, or bending different-shaped pieces of card stock. The compositions are based on different configurations of these pieces, arranged so that their shapes and sizes contrast and vaguely resemble everyday objects. This is an instructional exercise, but it's also fun to do.

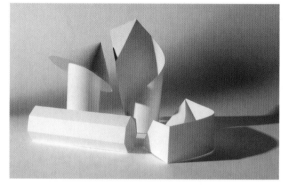

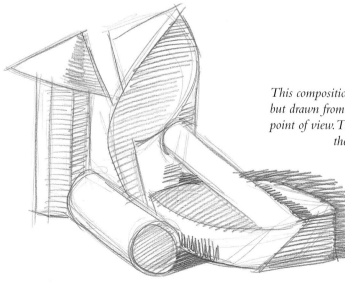

This is one of the studies for a composition based on forms fashioned out of card stock. Studies such as this allow you to examine the effect of each grouping and then decide which is the most interesting.

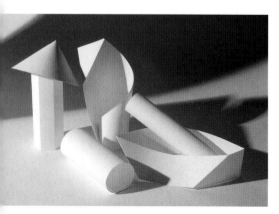

This composition is similar to the previous one but drawn from the perspective of a more elevated point of view. This vantage point noticeably alters the configuration of the forms: the roundness of the cylinder is more visible here, and the shape of each element is easier to appreciate. The lighting, however, adds some confusion to the scene.

These three studies represent three possible formats for a composition. Each reflects the demands of the volume of the different objects, the direction of the light, and the sequence of the shadows. Of the three, the last appears to be the most suitable, and we will use it to carry out the exercise on the following pages.

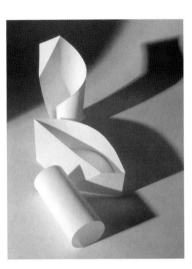

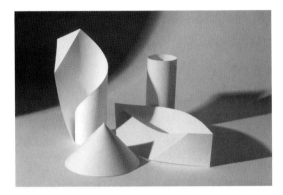

This elevated view of the motif completely alters the orientation of the composition: it becomes a vertical arrangement. This is an interesting possibility, but it diminishes the play of light and shadow.

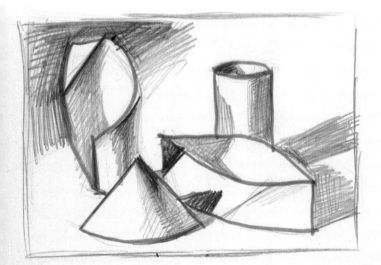

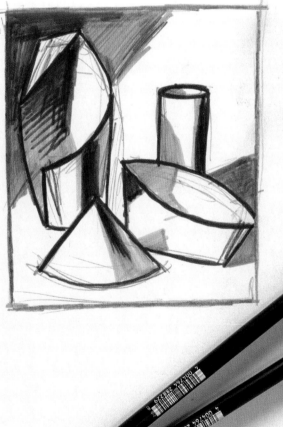

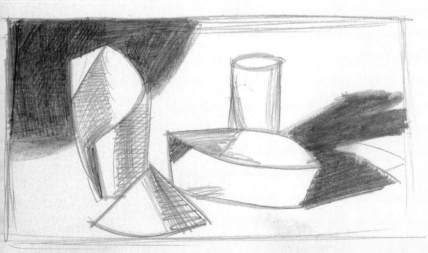

A STILL LIFE *with* ABSTRACT SHAPES IN CHARCOAL

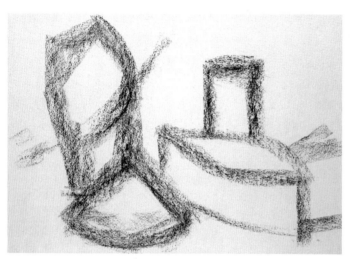

The subject of this exercise is undoubtedly peculiar. It is a grouping of shapes made from pieces of card stock, glued into different configurations. Besides a cylinder and a cone, there are two other shapes with clearly defined edges. The purpose is to forget real objects for a moment in order to concentrate on the essential play of light and shadow, independent of color and surface consistency. Abstracting the shapes, that is, clearing away the factors associated with real objects, allows us to concentrate on the essential aspects of tonal valuation and shading.

1

2

1. Create a geometric sketch of the shapes by dragging the tip of a charcoal stick on the paper to define with thick strokes the contours of each piece. As you've learned, you can modify and correct the shape of the charcoal stain with a cloth or by using your fingers. The cumulative smudges on the page can be cleaned up with an eraser.

3

2. When the geometric sketch matches the sizes and proportions of the shapes in our model, define the contours with a charcoal pencil, which has a denser quality and a darker, more precise stroke than the charcoal stick. Use a clean rag if you have to rub the surface of the paper. The lines of the pencil can't be erased as easily as the charcoal stick, so they remain visible. This ensures that the initial drawing contains only the necessary information, with no unnecessary markings.

3. The first shadings are tentative and shouldn't be darkened too much so that it will be easier to modify them later. Apply small spots of charcoal and then fade them with your fingertips, spreading them along the shaded sides of the objects. At this stage the tones do not yet require true valuations. For now, erase and repeat shading until the play of light and shadow matches that of the model.

4

4. The time has come to make a true tonal valuation, to adjust each shadow according to its intensity. The darkest shadows are made with a charcoal pencil, reserved for the advanced stage of the drawing because its lines are hard to erase. Alternating shadows in charcoal stick and pencil is only effective when some of the shadows blend into others, creating a sensation of continuous surfaces, which move gradually from light into shadow.

5. To create masses of black apply insistent charcoal pencil strokes until the entire paper is covered over. To unify these areas, fade and smooth out these strokes using your fingertips. The force of the black and white contrast lends vitality to this drawing, which is nonetheless subtle in the gradation of its tones. Here we witness a purity of shapes and contours, an abstraction of the basic principles and components of all still life drawings.

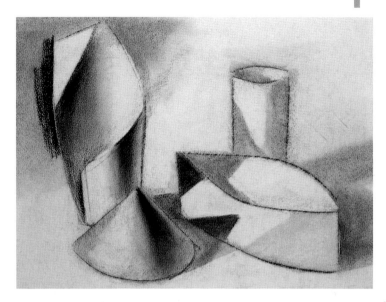

5

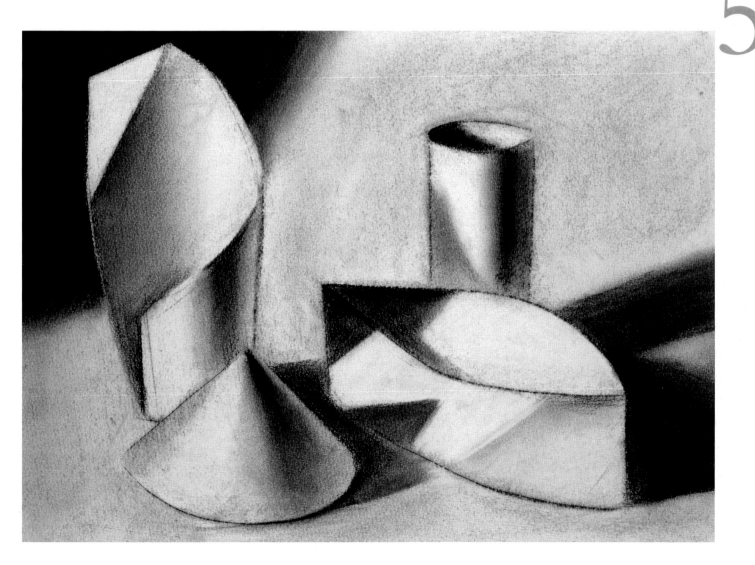

COMPOSITIONAL STUDIES
FOR A STYLIZED STILL LIFE DRAWING

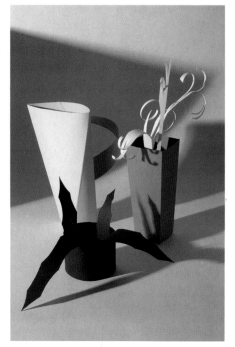

The subject for this exercise is once again a grouping of card stock constructions. This time the figures resemble real objects—a vase with flowers, a plant, and a pitcher—but they are stylized versions of what is typically seen in a still life. The "flowers" are curled strips of paper, and the plant is cut out of black card stock. Going one step further in the study of form, the purpose here is to focus on contours, planes, light and shadows. For that reason, the lighting is somewhat theatrical, with shadows projected against the background—dark screens on which the clear outlines of the objects will stand out.

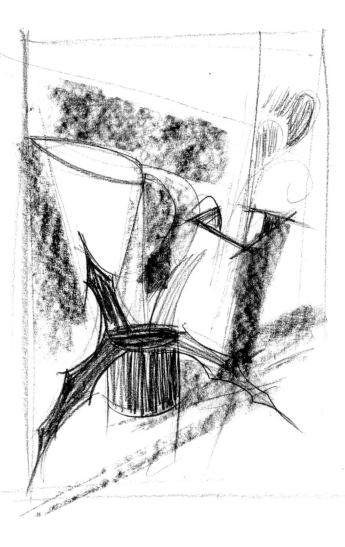

The purpose of the preparatory sketches is to integrate all of the elements into a single block, to arrive at a compact, coherent representation. The three objects form a more or less trapezoidal shape, and the leaves of the plant form an arch in the foreground. This way of interpreting the motif, finding the simplest and most prominent lines, establishes a solid linear guide and makes later steps easier. The distribution of light and shadow is part of this linear interpretation.

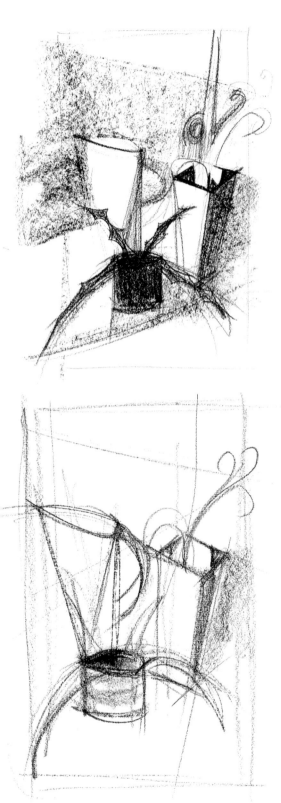

The goal of these sketches is to order light and shadows so that it recreates the volume of the objects. Shading consists of just a few strokes with a stick of compressed charcoal, which is darker and denser than conventional charcoal. The goal is to find a balance between light and shadow, between light blocks and dark blocks. This is an architectural approach to composition: your aim is to create a solid and harmoniously arranged "building." For this reason, the geometric regularity of card-stock shapes helps us focus on this aspect of the drawing.

When creating different objects with paper, the stock should be thick enough to support its own weight. Interesting figures can be made by folding or curling the paper without complicated cutting. You can even make interesting basic shapes with a single square of card stock, with no additional cutting.

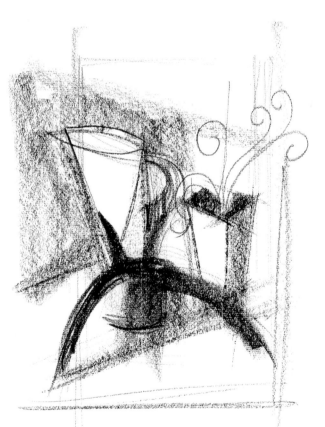

This sketch firmly establishes the compositional decision arrived at after making the previous studies. The arrangement of the compositional elements is clearly visible: trapezoids (the vase and pitcher) and an arch (the plant), both of which occupy the space of the drawing in its full dimensions.

This sketch defines the situation of light and shadow in the drawing. It is equally energetic, based on a clear distribution of a very few tones: the white of the paper, the gray of the objects in the middle ground, and the black of the plant in the foreground. With its strong contrast, this plant defines the space of the composition.

A STYLIZED STILL LIFE
IN PRESSED CHARCOAL

The sketches and studies on the last two pages developed the compositional foundation that Esther Olivé will use here to finish the drawing. The technique she uses is block shading, a logical next step after the earlier tonal valuations of the motif—although here there will be more than three tones at work in order to produce a more precise representation. Along with pressed charcoal, a violet hard pastel is used to add a pleasant, vivid touch to the play of light and shadow.

1. The conclusions we reached in the earlier sketches allow us to approach this composition with very clear ideas. Even if these sketches are not as energetic as the previous versions, the composition has a clear plan: trapezoids in the upper part of the drawing and an arch below.

2. The application of the first shadings follows the "architectural" principles that appeared in the preparatory sketches. The shaded areas have a very definite shape, suggested by the stylization of the elements that make up this still life.

1

2

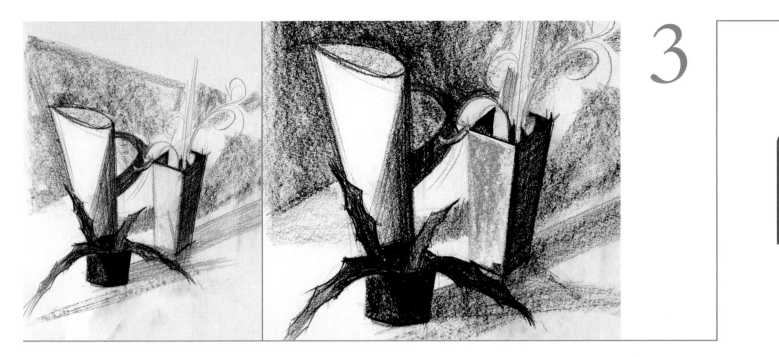

3

3. The shadows of the objects have a significantly darker tone than the background. As a result, their form stands out clearly and creates a sense of space. Similarly, the smaller plant stands out clearly and is pushed forward in the compositional space by its tone, which although very dark, contains a certain diversity and contrast in its tonal values. Esther Olivé has darkened the block of shadow in the background a bit more in order to unify the composition's lighting. At this advanced stage in the shading process, the tones begin to take on nuances so that the shadows delicately move toward the light. These nuances are added after the valuation of the shading blocks has been established firmly and unambiguously.

4. To finish the drawing the contours of the strips of paper that represent the flowers in the vase are darkened; this allows the light tones of the flowers to stand out against a backdrop of dark tones. Due to the energetic shading and the clear configuration of the card stock cutout shapes, the drawing is highly dynamic.

4

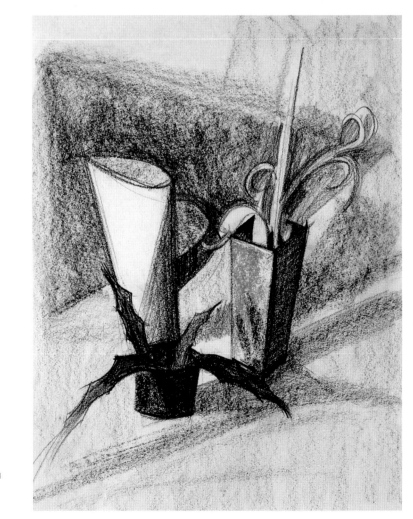

PREPARATIONS *for* DRAWING WITH INK SOLUTION

We have chosen an extraordinarily simple motif for this still life—a single lemon and a projection of a plant against the wall. But the simplicity is deceptive—the motif is, in fact, hard to draw because most of what is here is empty space. For this reason, Mercedes Gaspar chose to use water and ink solution. This medium allows the artist to create large, subtly nuanced and appealing atmospheres, which is exactly what is needed here. The following pages will show us how to use this technique.

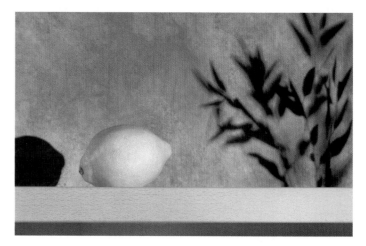

In terms of drawing, this motif presents no difficulties other than the choice of a proper framing. Limiting the drawing to the lemon and its immediate surroundings is too obvious and lacking in atmosphere. This subject requires the shadows at far right if it is to become a truly interesting motif for the artist.

The shadows of the leaves of a plant add appeal and variety to the solitary shape of the lemon. But this isn't the only reason why these shadows are interesting. Their appeal is largely a matter of space: the shadows bring a tonal value to the wall background and suggest distance, separating it from the plane on which the lemon rests.

Even the darkest ink will show gradations when dissolved in water. Its scale of values, from deep black to the most delicate gray, is wide.

The markings, strokes, and arabesque lines that are possible by applying a reed, pen, or brush to an ink solution make it particularly well suited to the representation of plant themes.

These touches of pure ink, used to represent the plant leaves, were applied with a reed pen onto a stain of still-wet, diluted ink. Small applications in ink tend to spread slightly, a property that makes them well suited to this theme, in which the shadows of some of the leaves are blurred rather than clear.

The ink used here is the same kind that is used in fountain pens. When dissolved in water the ink takes on subtle, graded tones. Spreading it with a small, soft-haired brush yields excellent results— atmospheric stretches of tone with a rich texture. These surfaces suggest atmosphere and also space.

The drawing problems presented in this exercise should be solved in the earliest stages of the work. The compositional sketch for this drawing is basic and can be rendered with just a few pencil strokes. The more interesting task is that of bringing nuance to the still life with the ink solution. Carefully dissolving the ink in water creates a spectrum of grays well suited to a somber atmosphere. Following the example of Mercedes Gaspar, you will apply an ink solution to large areas of the composition and unify the composition based on these applications.

A STILL LIFE *in*
INK SOLUTION

1

1. Apply the ink judiciously to the areas with the most light because ink is hard to lighten and even harder to erase. A small stain applied to the lemon will later be spread using a clean brush and water. The table is rendered as two bands with contrasting tones applied by using a small, soft-haired brush.

2. To spread the ink more easily, moisten the background of the composition with a sponge. The moisture of the paper will allow you to cover the background completely without leaving a trace of brushstroke. This monochrome wash procedure is a common watercolor technique.

2

3

3. The result of the monochrome wash is an area with a spongy texture loaded with different tones of gray. The darker parts are those in which more ink has gathered. The effect is highly atmospheric and will make the next step of rendering the shadows in the background a lot easier.

4. Apply spots of undiluted ink to represent the leaves' shadows before the background is completely dry so that the outline of the leaves is slightly blurred. The shadow of the lemon is applied once the background is dry, so its outline is clearly defined. With this simple but elegant final step, the drawing is finished.

4

PREPARATIONS *for a* DRAWING OF FLOWERS

The purpose of these preparatory studies is to see the graphic effects of mixed media—the term used to describe a combination of two or more media in a single drawing, in this case India ink and graphite pencil. Keep in mind that pencil is a somewhat oily medium and no water-based medium (including ink) will adhere to its strokes properly, so ink must be applied first.

The use of mixed media for this drawing is suggested by the graphic sobriety of the backlighted flowers. Esther Olivé will show us the steps for drawing this interesting and original still life with flowers.

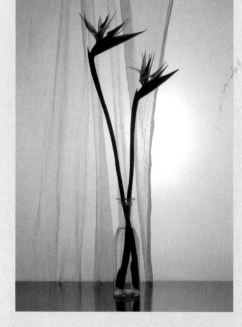

The backlighting that illuminates the still life turns the flowers into simple silhouettes that can be rendered in India ink. A few strokes are enough to draw the forms. Draw the tips of the flowers with fine strokes; the rest will be covered by broader strokes of ink.

The sketch confirms the effectiveness of using India ink to draw the flowers. Some pencil strokes have been applied to test their effect against the ink. The pencil's mark is much weaker, which makes it a good choice to model the shadows and the effects of transparency on the curtain that closes the composition from behind.

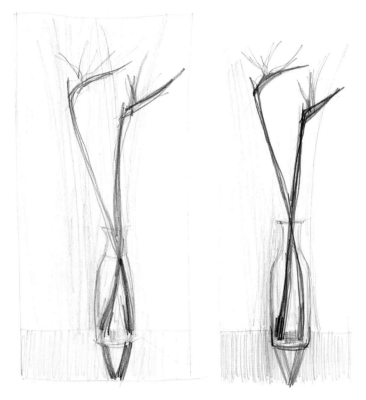

These two drawings combine pencil with very light pen strokes in the upper part of the flowers. The pencil option proves appropriate, especially in the representation of the curtain and the reflections on the table.

A definitive sketch that confirms the graphic effects of our mixed-media approach. Pencil and India ink are a particularly well-suited graphic solution for this still life.

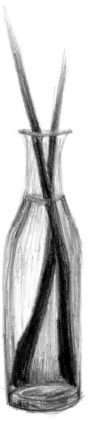

Here is a study of the details of the bottle. Pencil is an ideal medium for creating smooth, highly nuanced modeling, as seen in the treatment of the bottle glass. Nonetheless, the relative smoothness of pencil strokes compared to a pen's does not create sufficient contrast between the stems and the rest of the drawing.

These sketches were made in India ink, using a small fountain pen. Although ink is well suited to representing the transparency of the bottle, it lacks the subtlety and nuance typical of graphite pencil.

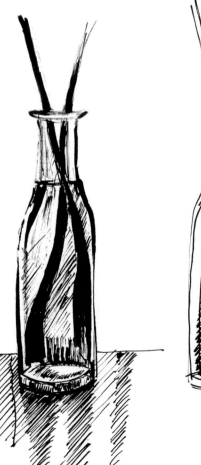

BACKLIGHTED FLOWERS
IN PENCIL AND INDIA INK

Now that we have verified the viability of mixing pencil and India ink, the final drawing of this backlighted still life can begin. The process begins with the India ink work. Once this is finished, we apply the pencil parts. The basic criteria that need to be considered in this drawing are its few elements and simple forms. The initial sketch and the composition should therefore not present any problems, especially after having already sketched several different studies for the subject in pen and graphite pencil.

1. The drawing of the flowers is made in India ink, working loosely and freely and using an uninhibited line. Drawing this way is much more effective for the representation of plants and flowers. Lines made too cautiously end up being too rigid and ill suited to the subject.

2. After touching up the stems a bit so that they appear cylindrical, put the pen aside and take up the pencil. The pencil used at this stage shouldn't be too soft—an HB or 2B lead will do. While later stages in the drawing will call for softer pencils, for the moment it is better to make softer, less visible marks.

3. The layering of fragile, elongated pencil strokes in the folds of the curtain creates an interesting suggestion of texture: a delicate, silky surface, the way a curtain in a still life ought to be. A too soft pencil would not have allowed this effect because its line is too intense and thick. The same is true of the surface of the table: the reflections are merely hinted at, due to the soft line of the pencil.

4. Intensify the previous tones using a softer pencil—a 3B or a 4B. The shadows in the folds are now darker, and help make the transparency of the crystal more apparent.

5. The surface of the table stands out in the final drawing. It is much darker than the rest of the drawing, and the high intensity of these tones brings the table surface closer to the foreground. Notice how the luminous background of the composition isn't white, as you might expect, but instead has been covered with soft crosshatching to integrate it into the graphic texture of the composition.

4

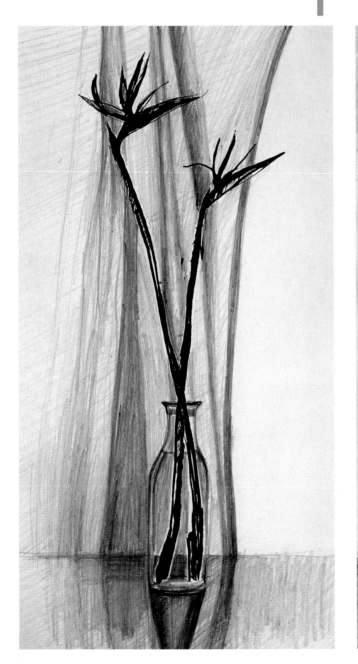

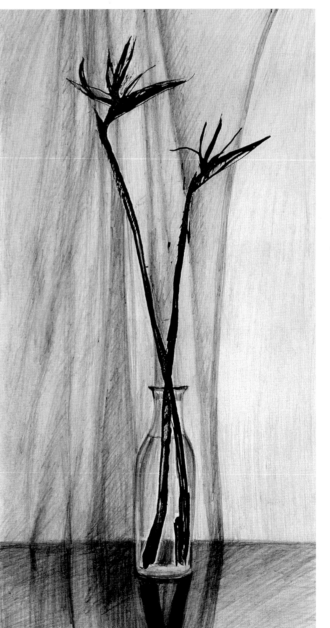

5

SPACE *and* ATMOSPHERE
WITH PENCIL AND CHARCOAL

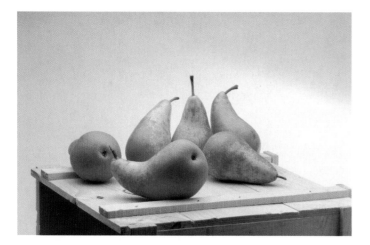

Still life drawing does not often contemplate an atmospheric representation of a motif. Among other reasons, the distances in a still life are short and there is little room to express great distances and perspective, as you can do, for example, in a landscape. But there is no strong argument to be made against avoiding atmospheric effects, as we saw in Mercedes Gaspar's still life of the lemon and projected shadows of a plant. In the following pages, she will show how atmospheric representation can be achieved by light bathing a subject such as these pears. Here, diffused light at the zenith of the composition produces few dark shadows and seems to envelop the fruits in delicate, white gauze.

1. The initial drawing poses no complications other than the proper rendering of the size and shape of the pears, relatively simple forms. The table or crate on which they sit is represented as a geometric shape in perspective. This drawing is purely linear. It is made in conventional black pencil because the lead in colored pencils is too oily and its tone too saturated.

2. Staining in charcoal consists of spreading spots of charcoal with the stick laid flat on the page. With this agile and effective technique the background appears as a light-toned veil and the parts of the table on which the pears rest are darkened.

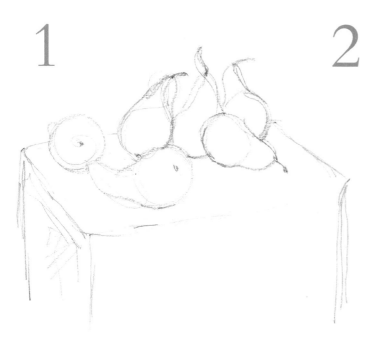

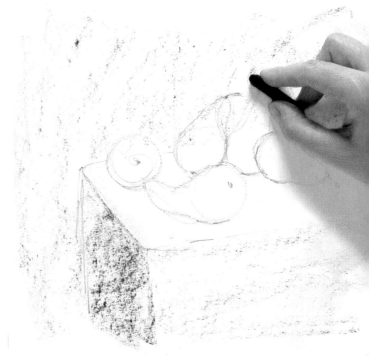

3

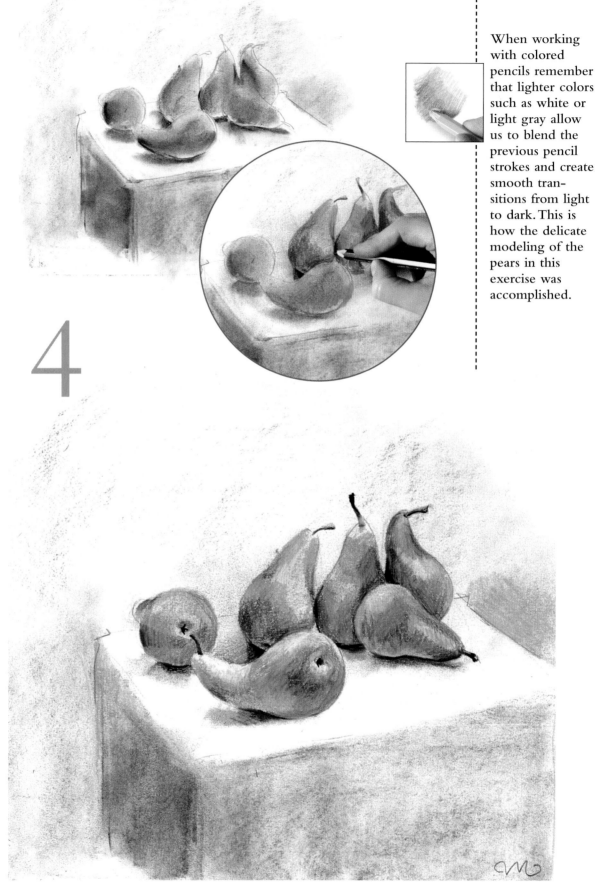

3. Next, these stains are faded and blended with a cloth in the upper part of the drawing and with our fingertips in the lower part. These fadings should also lightly model the volume of the pears. Add some nuances, using black and gray pencils over the earlier fadings on the surface of the fruits. The point is not so much to produce a conventional shading but to modulate the skins of the pears in shades of gray. Alternating between tones provides volume without exaggerating it, which could destroy the atmospheric effect we seek to achieve.

4. The success of the drawing is owed to the extraordinary subtlety of its modeling. Lights and shadows are divided evenly among the pears. Reflections and other nuances appear when we combine pencil and charcoal, and an atmospheric quality envelops this simple and suggestive still life.

When working with colored pencils remember that lighter colors such as white or light gray allow us to blend the previous pencil strokes and create smooth transitions from light to dark. This is how the delicate modeling of the pears in this exercise was accomplished.

A FRIEZE in CHIAROSCURO

A frieze lends solemnity to the subjects of a still life. Friezes are clear, sober compositions in which the elements are distributed horizontally, in complete equilibrium. The function of chiaroscuro in this frieze is to add drama to a subject that might otherwise seem dull. The artist Óscar Sanchís works here with white and sepia hard pastels on cream-colored paper. Part of the appeal of this exercise is the clarity found in the distribution of light and shadow, which perfectly match the lines of the composition, simple and minimal.

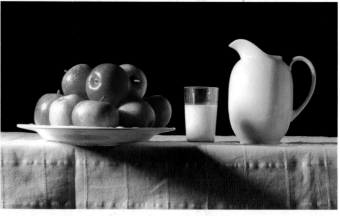

These two preparatory sketches lay out the essence of the composition and the lighting. The composition is divided in half by the horizontal line marking the tabletop. The diagonals that animate this horizontal line belong to the shadows cast by the tablecloth and the plate of fruit. Blocks of light and shadow divide the drawing into just a few areas with absolute tonal values.

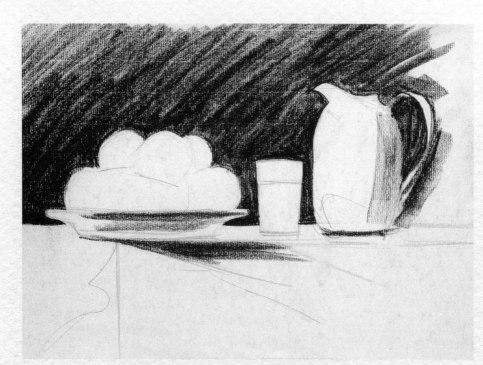

1

1. The simplicity of the initial drawing, based entirely on contour lines of regularly shaped objects, allows you to approach the arrangement of light and shadow from the very start, observing the essential lines of the composition. The horizontal line of the table marks the boundary of the darkness of the background, which will be covered entirely in a dense and uniform shading produced by layering energetic diagonal strokes.

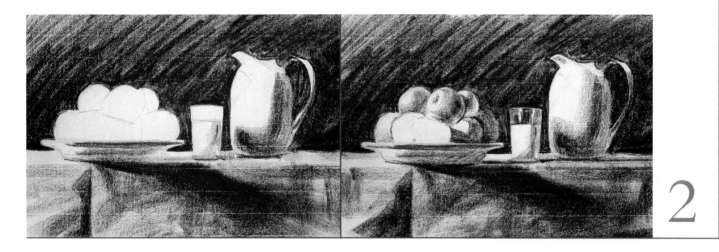

2. Notice that the shadows of the tablecloth are treated differently than the shadows in the background. For the background we used the tip of the pastel, whereas for the tablecloth the length of the sepia pastel is rubbed softly on the paper to achieve the diffused stains that effectively suggest the cloth's texture.

3. The shading of the background is rendered quickly due to the perfect definition of the lighted and shaded areas. All that is needed now is to model the interior of the objects. Do this carefully, taking into account the shape of each element so that its shadow is properly rounded. Just as with the tablecloth, apply the shadows by laying the sepia pastel flat on the paper.

4. Once the chiaroscuro effect is resolved, highlight some spots using white pastel. It goes without saying that you will apply these highlights to the areas of brighter white: the milk in the glass and the light parts of the pitcher. The light reflected on the fruits should not be embellished any further, because their tone—the white of the paper—is already right for the balance of light.

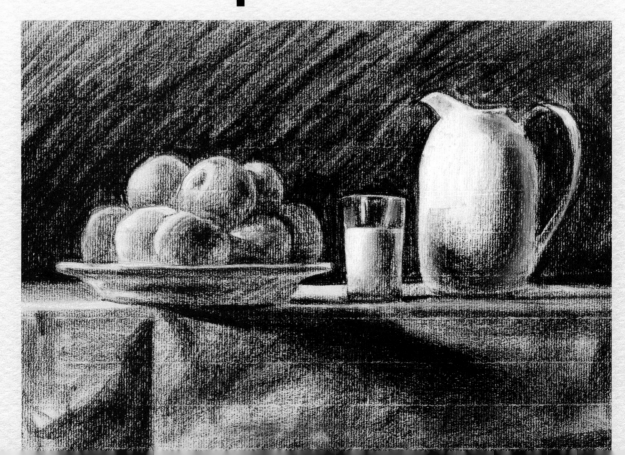

STILL LIFE *of* TOYS
IN REED PEN AND INK

Because of the size and distribution of the toys in this still life, they could be figures in a painting of an interior, if not for their inanimate nature. We have a papier-mâché horse, a plush bear, and a mobile of birds. The composition is casual—the framing of the image leaves out much of the horse's body. Mercedes Gaspar will place special emphasis on the play of light and shadow that develops in the middle of the scene and which accentuates its particular atmosphere. This exercise is done in India ink applied with a reed pen and a final wash of ink solution.

This drawing in reed pen is not part of the exercise. It was drawn earlier as a study to establish the graphic distribution of the lines in the composition. The objects are described with a melodious rhythm in the line.

1

1. The initial drawing is in pencil and is quite scrupulous with respect to the contours of the objects—the definition of each one is clear and precise. Mercedes Gaspar has applied some strokes of white, oily pencil in the lighted parts of the birds, which will keep this part of the drawing from being accidentally covered by the ink wash that follows.

2

2. The wash of ink solution, applied with a sponge, is followed by reed strokes. The plush bear is white and takes in the light almost directly. The artist has reserved the bear area in white so that she can go to work on it in a later stage of the drawing. The layering of strokes creates a particular texture that directs your attention toward the center of the drawing.

3. These stains are applied with a pen dipped in diluted ink, so that the strokes are lost and blent together in several parts of the drawing.

Using an oily white pencil or a white crayon reserves the parts of the drawing that must remain completely white. The ink will slide off the pencil or crayon marks, leaving those areas intact.

3

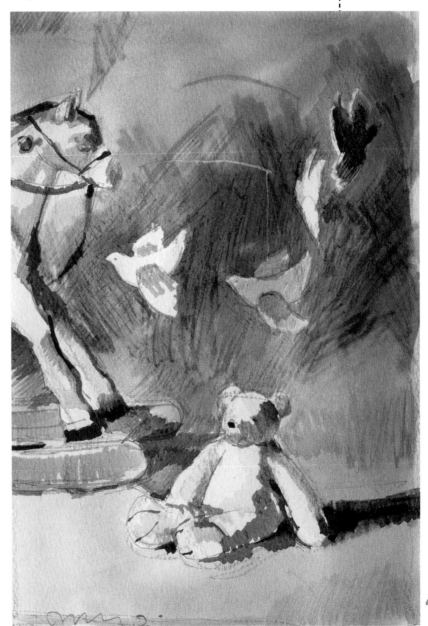

4. The last step consists of adding new strokes of ink solution, some more diluted than others, until the lighting of the entire scene is unified. It is important that the birds in the mobile appear to occupy different positions in space, and the artist has done this by grading the tone of their shadows to suggest the central space in the composition.

4

STUDIES *for a*
DRAWING OF DRAPING

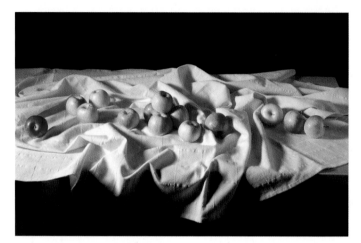

Draping has been studied in this book as a recurring motif in still life drawing, and this exercise focuses on the folds and wrinkles of a tablecloth as the main element of the drawing. In this motif, the apples merely provide a figurative counterpoint to the labyrinthine structure of the volumes created by the folds of the tablecloth. This page shows a detailed study of this motif—detailed because as the folds give rise to one another it is impossible to understand any one of them without taking into account the others. The simultaneous contrast of the chiaroscuro emphasizes the relief of the tablecloth with a view toward the final drawing.

Even if the final work will be in chiaroscuro, the structure of the folds and wrinkles is better studied in terms of line. The angles, curves, and abrupt shifts in direction of the draping are more clearly visible in a strictly linear drawing such as this. It is important to make several sketches, paying attention to the trajectories of the most significant folds, before approaching the definitive work.

The central area in this motif is the most complex. This linear rendering emphasizes the most significant relief and volumes created by the folds and the apples. The purpose is to establish a formal contrast between the simple, closed volumes of the apples and the open, dispersed forms of the folds. Shading is reduced to a minimum and is summarized as a simple series of strokes.

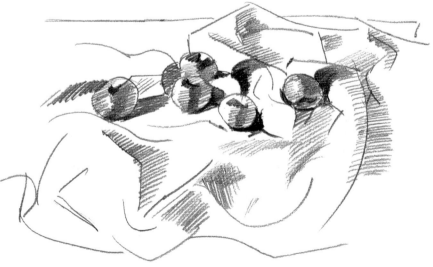

This drawing establishes the basic contrast in the drawing: the white of the tablecloth against the black of the background. From a compositional point of view it is important that there be a visual equilibrium in this contrast, that is, the black should serve to valuate the tone of contours in the lighter shapes, which should in turn make the background appear defined, not vague or uncertain.

This drawing combines the basic relief of the folds and the contrast of the tablecloth's white tone against the darkness of the background. The central folds are treated with more confidence and efficacy than in the previous studies, and as a result, relief and volume are clearer and more definite.

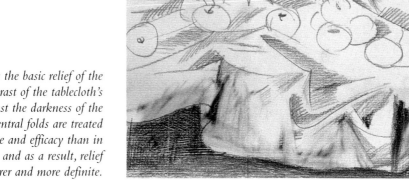

The most volumetric part of the composition is the center of the tablecloth, where it gathers and bunches up in a baroque assemblage of bulges and creases. What stands out is that the darkest parts of the tablecloth match the general shade of the background—the area where the white of the table is integrated into the black of the background.

CHIAROSCURO *of*
DRAPING IN PENCIL

Once the preliminary studies are completed, we can begin the final drawing, as done here by David Sanmiguel. The process depends upon what the preceding studies have shown: the linear description of the folds in the tablecloth, the general contrast in the composition, and a detailed rendering of each of the lights and shadows of the apples and the creases in the cloth. The goal is to achieve a detailed and accurate representation of the whole ensemble of folds that is integrated with, and doesn't weaken, the powerful contrast of the lighting.

1

2

1. This detailed line drawing is a direct product of the earlier studies. The complex configuration of lines is rendered as precisely as possible We do not draw the folds, however, because that would produce a contradictory or confusing result that will have to be corrected later.

2. The background has been almost entirely shaded, which brings out the exact contours of the table and tablecloth. We can clearly see the pencil strokes, which are applied all in the same horizontal direction. We leave the lower part blank, saving it for the play of light and shadow that connects the draping to the darkness of the background.

3. Proceed with the shading of the folds from left to right to avoid having your drawing hand (the right, in this case) smudge what we have already drawn. It is better not to emphasize the apples' shadows too strongly now, as this serves to avoid unevenness between them and the tone of the folds.

3

4

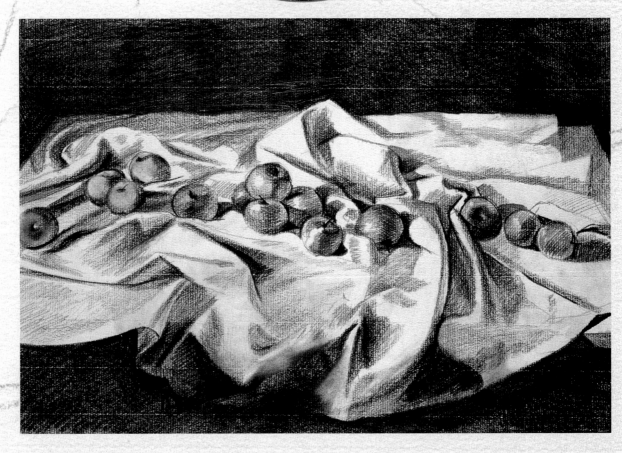

The thickest folds in the draping are modeled care-fully, emphasizing their volume. There is no reason not to render them as solid forms if doing so creates a more vivid sensation of volume and depth.

4. The lower part of the folds is where we find the most complex part of the modeling process for the tablecloth. Alternating between very dark shadows and very light raised areas brings out the most vivid volumes in the draping at the same time that it integrates it into the darkness surrounding the table. Likewise, we work on the apples just as we have on the folds of the tablecloth.

5. In the last phase of the drawing we reinforce the shadows of the apples to emphasize their volumes and have them stand out against the tablecloth. This can only be done after the many different tones of the fold are fixed. The result is a highly nuanced drawing, with a delightful balance between its light and shadows.

5

STUDY *for a*
COMPOSITION WITH GLASS CONTAINERS

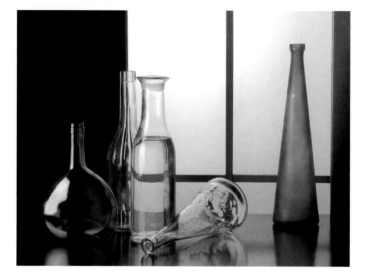

Glass or crystal is a difficult material to draw. The uninformed viewer tends to admire the virtuosity of painters of decanters, glasses, and luxurious crystals, assuming that rendering such objects is an awesome and notable achievement. This is a reasonable opinion, but a still life shouldn't be judged by its realism but by the expressivity and unity of the whole, and to reach that unity it is sometimes necessary to put imitative virtuosity aside. Here, Óscar Sanchís shows how this is done in a series of compositional studies of glass containers.

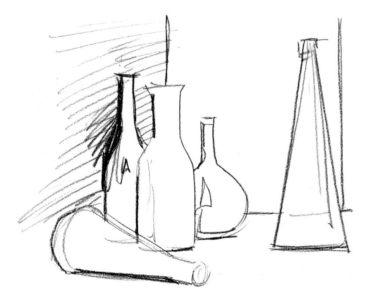

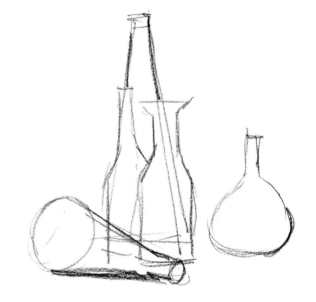

The distribution of space in this drawing is determined by the square in the background, which might be the presence of a window (and therefore, a backlight). This structural element organizes the drawing by opening up a space in the center, with the containers spread out to the left and right of the frame. This solution is somewhat more satisfactory than the simpler composition to the right because it is more varied.

This sketch and those that follow show different combinations of glass containers with a view toward rendering them in chiaroscuro. The harmonious arrangement of the containers is every bit as important as their actual rendering. This sketch is a centered composition dominated by the vertical orientation of one of the bottles, which determines the placement of the other containers around it.

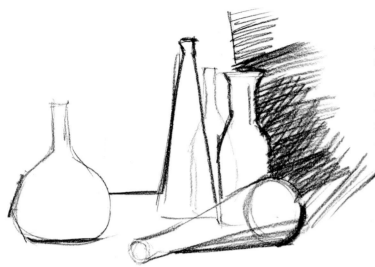

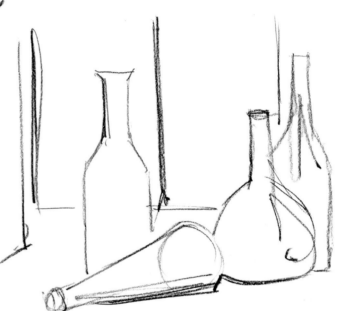

A composition in the shape of an inverted "L." The central opening is displaced toward the right and is now partially outside the frame. The overturned bottle on the table now points in the opposite direction and the artist suggests darkness in the right-hand side of the frame to compensate for the great white center. With all this, the result is somewhat imbalanced, for it is too heavily weighted toward the right.

Here again the composition is centered around the geometric frame of the central window. This frame determines the general schema, but there does not appear to be an agreement between the central vertical rectangle and the spread of the objects.

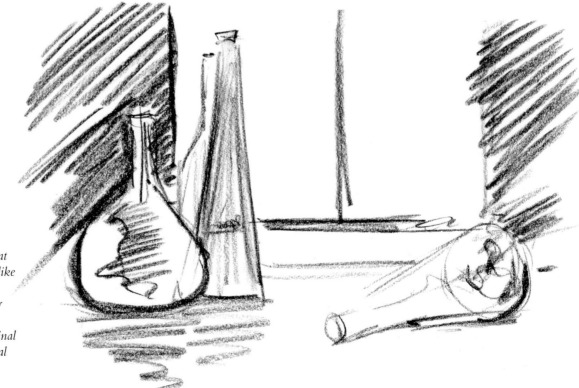

In this simplified version of what the final composition will look like the window is centered and the darkest areas are found to either side of it. These are not all the objects that will appear in the final work, but now we have a general guide for how to proceed.

TRANSPARENCY,
REFLECTIONS, AND SHINE IN
CHIAROSCURO

The motif of the exercise begun on the preceding pages is composed of several glass containers, all of them transparent and translucent, in a frieze composition. The backlighting produces a powerful chiaroscuro effect that brings out the sparkles in the ensemble. Óscar Sanchís did this still life with a very dense Conté charcoal stick. He searched for clean and energetic contrasts that defined each object clearly and underscored the expressivity of the cold brightness of the glass.

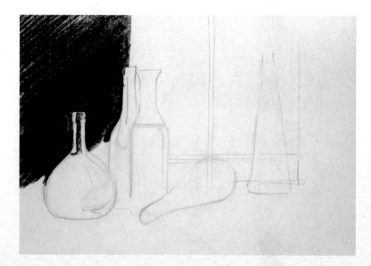

1

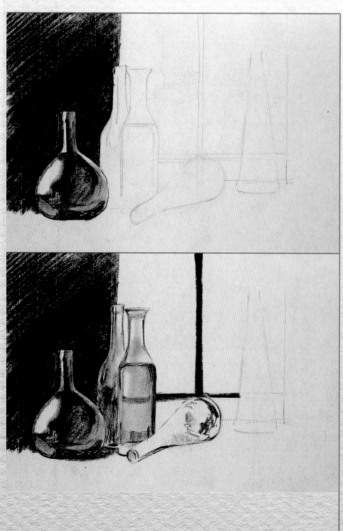

1. Instead of a progressive approach to light and shadow, the chiaroscuro process begins at the very outset of drawing, with a powerful contrasting of black against white, which highlights the shine on the bottle submerged in light. The charcoal stick is used as if it were a pencil with a thick line, covering the paper completely with overlapping strokes.

2. The transparency of the backlighted bottles is reproduced with very faint shadings. To guarantee that softness work with a stumping tool or with a fingertip stained lightly with charcoal. Note how the crossbeams of the window frame are distorted through the cylindrical shape of the bottle.

2

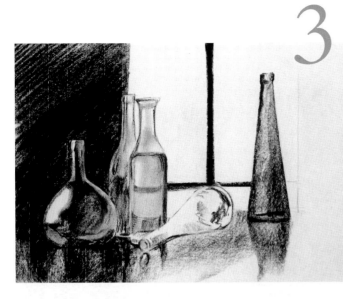

3

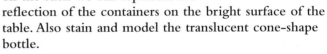

3. Use the charcoal stick to work on the table. The difference between the stick and pressed charcoal is that its mark is less intense and it allows for intermediate grays if we place it on its side and drag it along the paper. By exerting greater or lesser pressure on the stick we can represent the reflection of the containers on the bright surface of the table. Also stain and model the translucent cone-shape bottle.

4. On the right side of the composition we once again use Conté charcoal stick to get a black tone equivalent to that on the extreme lower left of the drawing. This counterweight is necessary to balance a drawing that would otherwise be lopsided, with one of its sides "heavier" than the other.

4

Every valuation of light and shadow brings with it an implicit pictorial sense. A proper arrangement of tones always suggests color. We can appreciate this by looking at the result of this interesting drawing exercise in crayon by Mercedes Gaspar. Crayons are usually used by schoolchildren, but in the hands of an artist they yield excellent results. Here the artist works basically with white, black, and gray crayons, while a touch of blue adds nuance to their monochrome. The subject is a grouping of small toys, to which we have added a curtain to set the scene of this composition.

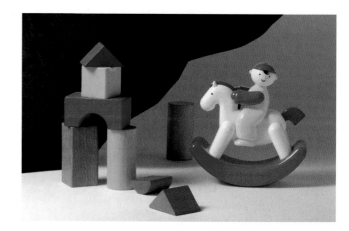

SMALL STILL LIFE
WITH TOYS, IN CRAYON

1

1. Whenever you use white pencils (or chalk, dry pastels, or crayons), you must choose a paper whose color allows the white to stand out. In this case we use a light-gray paper that perfectly combines the black and white tones in the work. The initial drawing is a geometric sketch that arranges the forms in the composition freely, with no consideration for the accuracy of their contours, which we will take care of later with light and shadow.

2. The extreme black and white tones come first, and define the basic form of the composition. Naturally, we will add detail and nuance to these colors throughout the process, but the general effect of the drawing will remain virtually unchanged. That effect is what the artist has sought from the start.

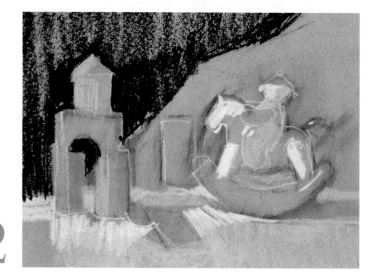

2

3

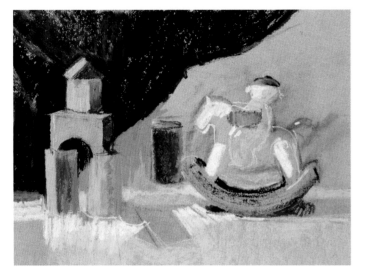

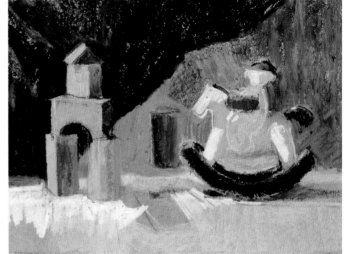

4

3. Add nuance to the dark tones with the blue crayon, and touch up the whites with gray. Blue is a cold color, suggestive of distance or depth, so it makes sense that background planes contain some blue details. At this point the gray paper has become integrated into the composition as another tone in its palette.

4. Load the background with different details and nuances, all of them partially blended into one another (crayon strokes blend together when rubbed). The solid black of the curtain acts as a screen against which the building blocks stand out.

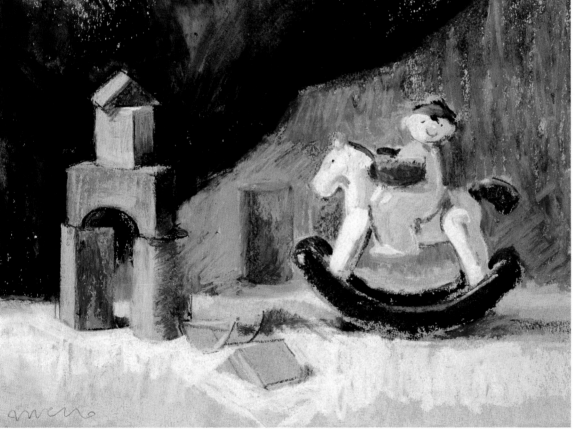

5

5. Leave the smallest shadings, nuances, and details for last. This way the details of the horse and the wooden blocks remain visible. The pictorial richness of this drawing clearly defines the distance and spatial relations between the objects, and at the same time creates a charming atmosphere that agrees with the subject.

Index